ni

EDINBURGH
by Smartphone

In easy steps is an imprint of In Easy Steps Limited
16 Hamilton Terrace · Holly Walk · Leamington Spa
Warwickshire · United Kingdom · CV32 4LY
www.ineasysteps.com

Notice of Liability
Every effort has been made to ensure that this book contains accurate and
current information. However, In Easy Steps Limited and the author shall
not be liable for any loss or damage suffered by readers as a result of any
information contained herein.

Trademarks
All trademarks are acknowledged as belonging to their respective
companies.

In Easy Steps Limited supports The Forest Stewardship Council (FSC), the
leading international forest certification organisation. All our titles that are
printed on Greenpeace approved FSC certified paper carry the FSC logo.

MIX
Paper from
responsible sources
FSC® C020837

Printed and bound in the United Kingdom

ISBN 978-1-84078-978-2

Contents

5 Hidden Edinburgh Photos 105

6 Old Town Walk 127

7 New Town Walk 141

1 Introducing the Guide

Edinburgh by Smartphone is the essential innovative guidebook for the digital age for getting the most out of a city break to Edinburgh, with your smartphone as your travelling companion.

This chapter explains the purpose of the guide and shows how it can be used to locate and photograph iconic and less well-known locations around the city, and also enjoy a range of different walks around Edinburgh. It shows how to get the most out of the walks, with step-by-step details including historical information, photo opportunities, and refreshment stops.

The what3words app is used throughout the book to identify locations for photos and walks, and there is a detailed look at the app, showing how to use it to identify locations, get directions to each reference point, and also save favourite locations so that you can quickly find them with a single tap.

About this Guide

Edinburgh by Smartphone is a guidebook for the digital age, to help you get the most out of a city break visit to one of the world's great cities.

The book focuses on two of the main areas that are undertaken on city breaks – photography and walking – and shows the related information needed to explore all aspects of the city, from fun facts to places to eat and drink.

Photos

For each photo in the book, the **what3words** app is used to give a precise location from where to take the photo. **what3words** works by dividing the entire globe into three-metre squares (57 trillion in total) and giving each square a unique three-word designation. It is therefore possible to identify the exact spot where certain photos are taken: the book

contains photos for each location and their **what3words** designation. (See pages 12-22 for details about using the **what3words** app.)

In addition, the exact direction to be facing when taking a photo is also listed. This is done using a compass app on a smartphone, and if there is not one on your smartphone already, one can be downloaded from either the Apple App Store or the Google Play Store. Follow the compass directions in the guide to be in

the correct position to take a photo. The best time of day for taking a photo is also listed, to get the best possible lighting conditions (weather permitting).

...cont'd

The types of photos used in the book are listed in two categories: iconic shots to show postcard-type photos that people associate with the location; and more obscure, hidden photos that will help you discover hidden gems around the city.

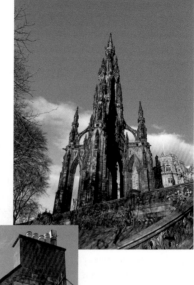

Each photo has directions for getting to the required location; **what3words** references; photo facts about items in the photo; nearby locations of restaurants, cafés and pubs; other nearby attractions; selfie spots; and other photos that can be captured from the same location.

Walking

Because of its compact size and wealth of historical and eye-catching features, Edinburgh is an ideal city to see on foot. The book details a number of walks that capture the full character of Edinburgh:

- Edinburgh's Old Town

- Edinburgh's New Town

- Literary characters

- Dark Side

- Water of Leith

- Arthur's Seat

The walks are detailed in a step-by-step process, which tracks the route of the walk and identifies notable features along the way. The length of each walk is listed, along with the approximate number of steps (for those watching their step count each day). Each walk includes suggested photo stops, refreshment stops and historical notes. The **what3words** app is used to provide directions and identify points of interest or importance along the walk; e.g.:

6 Continue along the Royal Mile and stop at **what3words** ref: **phones.fortunate. chips** to view John Knox House, the former home of the Scottish religious reformer

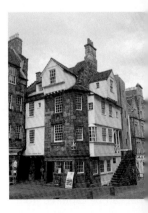

Symbols in this Guide

The symbols used the book are intended to provide additional information relating to a specific photo or the area in which it is located. The symbols are:

Getting there: This includes directions for getting to the photo spot from a central point in the city. **what3words** references are used for the directions – e.g. **digit.slate.stage** – to get to the location.

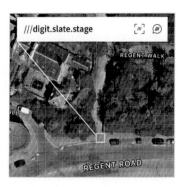

Photo fact: This contains useful, interesting or just fun information about items in the photo or nearby.

Nearby food and drink: This details restaurants, cafés and pubs that are near to the photo location so that you can stop for some refreshments before or after you take a photo. Each establishment is on TripAdvisor, so their details and reviews can be checked as required.

Nearby attractions: This lists attractions that are near to the location of the photo spot. The attractions can be either modern or historical, and each one is given a **what3words** reference. The attractions will cover all areas of Edinburgh life to give a more varied sense of the city.

Selfie spot: This identifies locations that are ideal for taking selfies, with notable items in the background. This can be done with a selfie stick or just with your smartphone camera.

Using what3words

Finding locations and tourist attractions can be a time-consuming task when you are in a new city, and this could be time that you cannot afford if you are on a short city break. However, help is at hand with an app that can guide you to any location in a city or anywhere in the world through the simple use of combinations of three words.

The app is called **what3words** and it can be downloaded from Apple App Store for an iPhone and Google Play Store for an Android smartphone.

what3words works on a simple but ingenious premise: it divides the whole globe into three-metre by three-metre squares and gives each of them a unique three-word designation. So, if you are standing at the bottom of the Eiffel Tower, you can find your exact **what3words** location with a single tap of the app. Similarly, if you are given a **what3words** reference, you will be able to go to the exact location mentioned.

The photo sites and landmarks in this book are all described with their **what3words** location, and they can all be located exactly using the app.

The **what3words** app uses a grid over a map view or a satellite view, and each square represents a three-metre by three-metre location. The maps can be zoomed in on or zoomed out from to see a location in more detail or view it within the context of a larger area.

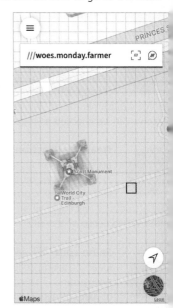

Finding your current location

The **what3words** app can be used to quickly find your current location and display its **what3words** description. To do this:

1 Open the **what3words** app

2 Tap on this button

3 The current location is displayed on the map, denoted by a square with a black outline (in map view)

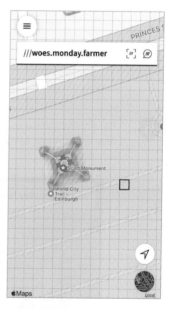

4 The **what3words** description is displayed in the text box at the top of the window

///woes.monday.farmer

5 If you zoom out on the location (pinch inwards on the screen with thumb and forefinger) the location icon changes from a square with a black outline to a solid dark square, with the **what3words** logo

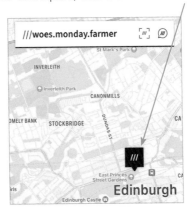

6 Tap on this button to see a satellite view (the location box outline turns white in this view)

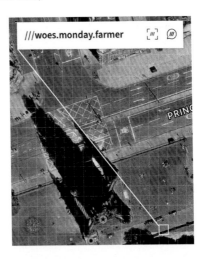

Finding a what3words location

If you are provided with a **what3words** reference, such as the sites and locations throughout this book, it is a straightforward task to find the location:

1 Tap on the text box at the top of the window to access the Search box

2 Enter the **what3words** reference with a full stop (period) after the first two words but not after the last one. Suggestions that are similar to the reference are displayed below it. Tap on one of the suggestions or tap on the **Go** button to display the reference in the text box (pay particular attention when entering plurals)

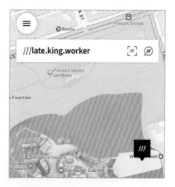

Finding named locations

Instead of using a **what3words** reference, it is also possible to find named locations such as streets or landmarks:

1 Tap in the **what3words** Search box and enter a named location. Tap on one of the results to view the selected location

2 The location is displayed on the map, with its **what3words** reference displayed in the Search box

3 Pinch inwards on the screen with thumb and forefinger to zoom out of the location and view it in a wider context

4 Tap on this button to view a satellite map of the location

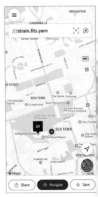

Scanning references

In addition to typing a **what3words** reference into the app to find a location, it is also possible to scan an existing reference, such as those in this book, using the app itself. To do this:

1 Open the **what3words** app and tap on this button in the text box at the top of the window

2 Position the scan box over a **what3words** reference (where possible, the

what3words references in the book are produced on a single line, to make it easier to scan them)

3 Tap on one of the suggested **what3words** references

4 The location is shown on the current map type; e.g. map or satellite

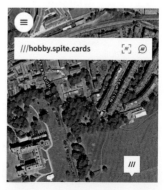

Speaking references

what3words references can also be located by speaking three words into the app. To do this:

1 Open the **what3words** app and tap on this button in the text box at the top of the window

2 The app will ask for access to your device's microphone. Accept this and then speak the required three-word reference (punctuation is not required – just the words on their own)

3 Voice searching is not always an exact science. Possible matching options are listed. Tap on one to view its location, or tap on the Speech icon again to perform another voice search

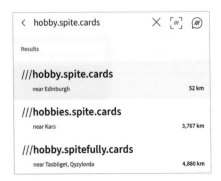

...cont'd

Getting directions

Once you have found a **what3words** location, you can use the app to find directions to it from your current location. To do this:

1 Find the required location in the **what3words** app

2 Tap on the **Navigate** button at the bottom of the screen

3 Select an option for how you would like to navigate to the location – usually a maps app

4 Use the selected maps app to navigate to the location. Tap here to find directions to the location

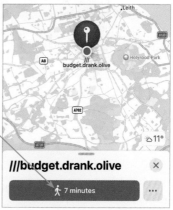

5 The route is displayed. Tap on the **Go** button to start the directions. Your location is marked on the route, and this moves as you travel along the route

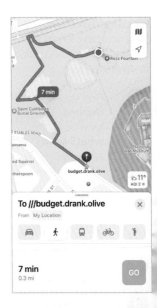

6 A spoken narration guides you along the route with directions. These change as you move along the route until you arrive at your destination

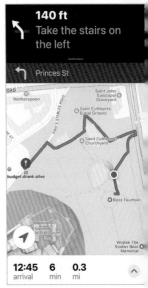

...cont'd

Saving favourites

If there are locations that you want to visit regularly, you can save these as favourites so that you do not have to enter the **what3words** reference each time you want to view the location. To do this:

1 Find the required location in the **what3words** app. Favourite locations can be saved from anywhere, so they are saved and ready for when you visit the location

2 Tap on the **Save** button at the bottom of the screen

3 The location is saved to the **Favourites** section of the app, indicated by the **Saved** button

4 Tap on the **Menu** button in the top left-hand corner of the screen to view all of your favourite locations

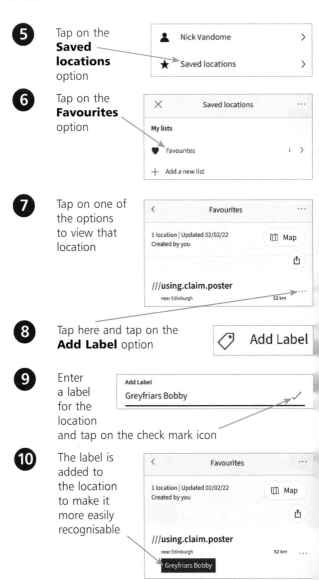

5 Tap on the **Saved locations** option

| 👤 Nick Vandome | > |
| ⭐ Saved locations | > |

6 Tap on the **Favourites** option

| × | Saved locations | ... |

My lists

❤ Favourites 1 >

\+ Add a new list

7 Tap on one of the options to view that location

< Favourites ...

1 location | Updated 02/02/22
Created by you 🛄 Map

📤

///using.claim.poster
near Edinburgh 52 km ...

8 Tap here and tap on the **Add Label** option

🏷 Add Label

9 Enter a label for the location

Add Label
Greyfriars Bobby ✓

and tap on the check mark icon

10 The label is added to the location to make it more easily recognisable

< Favourites ...

1 location | Updated 02/02/22
Created by you 🛄 Map

📤

///using.claim.poster
near Edinburgh 52 km ...
Greyfriars Bobby

2 Smart Edinburgh Essentials

When visiting any new city you want to be able to hit the ground running (or at least walking briskly!) when you arrive, to make the most of your time there. This chapter covers some essential information about Edinburgh so that you can get a good understanding of the city and its essential sights before you even arrive.

Edinburgh has had a long, rich, and – at times – bloody history that has shaped the city and also much of Scotland. Important historical dates are included in this chapter, and historical events are also included throughout the book.

This chapter also looks at some practical information, including getting into town from the airport; getting around the city with public transport, cycling and walking; and some of the culinary delights to be savoured. Finally, there is information about what can be an essential service in a time of need – free public toilets!

All About Auld Reekie

It is hard not to be captivated by Edinburgh: it is steeped in history, compact enough to get around on foot to most locations, and everywhere you look there are stunning views or buildings. Some of the features of Edinburgh that can be enjoyed during a city break or a longer stay include:

- World-renowned sights such as Edinburgh Castle and the Scott Monument.

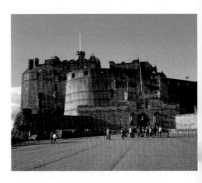

- Cobbled streets and tenement buildings in the Old Town that contain historical secrets of the city.

- Impressive houses and streets of the New Town that indicate the affluent financial history of Edinburgh.

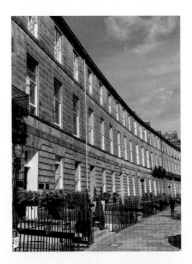

- Arthur's Seat, looming over the city and guarding historical details about the area's geological past.

- The grandeur of Holyroodhouse Palace – the monarch's residence when in Scotland's capital.

- A range of walking routes, covering everything from the historical villains of Edinburgh to the tranquillity of the Water of Leith.

- The engaging story of Greyfriars Bobby, the terrier who captured the hearts of animal lovers around the world.

- Restaurants, cafés and pubs for all tastes and budgets, featuring Scottish favourites such as haggis and whisky.

- Modern architecture such as the Scottish Parliament building at the foot of the Royal Mile and the "Ribbon Hotel" in the St. James Quarter.

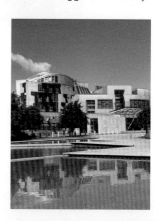

What's in a Nickname?

Edinburgh's nickname, Auld Reekie, does not refer to any of the more eye-catching aspects of the city, but rather a less salubrious feature of its history. Auld Reekie is Scots for "Old Smoky" and refers to the days when coal and peat fires were ubiquitous in the city, resulting in thick, dark smoke that frequently shrouded Edinburgh and its inhabitants. Evidence of this is still seen today, with some buildings such as the Scott Monument darkened by smoke, as opposed to their original sandstone colour.

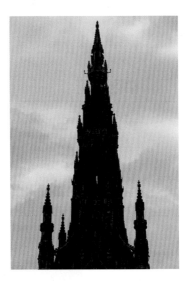

Modern-day Edinburgh does not suffer the same problems as in earlier years, largely due to bans on burning fuels such as coal and peat, but the historical influence of Auld Reekie still continues with many of the city's buildings; a local joke is that some of the buildings around the city are only held together by the soot and dirt they have accumulated over the years.

Edinburgh City Council is also trying to cut down on modern-day pollution by limiting car use in the centre of the city. Measures like this are ensuring that Edinburgh's nickname can very much be consigned to the past.

It Paid to Look Up

One of the main features of Edinburgh's Old Town is the closely-packed tenement buildings. Today, they are highly sought-after properties, but historically they contributed to overcrowding and generally unsanitary conditions for those who lived there. Until the 18th century, any form of indoor

plumbing or toilet facilities was unheard of, resulting in the famous Edinburgh cry of "Gardyloo" when the waste water from a household was thrown out of the window! From the French "gardez l'eau" (beware of the water) it took on a meaning all of its own, and Edinburgh citizens became familiar with avoiding this airborne peril.

The use of French for this waste-related warning dates back to the Auld Alliance between Scotland and France (first signed in 1295 between John Balliol of Scotland and King Philip IV of France), designed primarily to protect the respective nations against attack by the English. The alliance endured for nearly 300 years, leading to close ties between the two nations, including the marriage of Mary, Queen of Scots to the future king of France, Francis II, in 1558. However, this was the last formal act of the Auld Alliance, and although it was never formally revoked, it is generally thought that it came to an end in 1560 with the signing of the second Treaty of Edinburgh.

History of Edinburgh

Edinburgh has a rich historical heritage, much of it built on the four pillars of politics, religion, commerce and the law. It has not always been Scotland's capital, but for hundreds of years it has been pivotal for the country's development. From political intrigue with kings, queens and politicians, to religious confrontations, to the development of banking, insurance and legal systems, Edinburgh has been at the forefront of most of the most major events in history that have shaped Scotland.

History timeline

1100. A town grows up near to what was to become known as Castle Rock at Edinburgh, due to its proximity to the Firth of Forth and its advantageous defensive position.

1128. David I founds Holyrood Abbey, later to be the site of Holyroodhouse Palace.

1296-1322. The Scots and English battle for control of Edinburgh Castle, with the Scots recapturing it in 1322.

1328. The first Treaty of Edinburgh is signed, bringing peace between Scotland and England.

1329. Edinburgh is given a charter by Robert the Bruce (a document granting the townspeople certain rights), setting it on its road to becoming the country's capital.

1437. James I is murdered at Perth, the country's old capital. Following this, Edinburgh becomes the main royal residence and site of parliaments.

1501-5. James IV builds Holyroodhouse Palace.

1513-60. Following defeat by the English at the Battle of Flodden, a defensive wall is constructed around the city, known as the Flodden Wall.

1528. James V – father to Mary, Queen of Scots – enters Edinburgh and asserts his right to rule. His reign included strong support for the Catholic church at a time when Henry VIII was breaking away from Rome.

1532. The Court of Session was formally set up in Edinburgh by James V.

1544. Henry VIII tries to bring Scotland under English control by means of an arranged marriage between Mary, Queen of Scots and his son, Prince Edward. Known as the Rough Wooing, it resulted in the burning of Edinburgh Castle.

1559. Town council appoints John Knox, the religious reformer minister at St. Giles.

1560. The second Treaty of Edinburgh is signed, ending French involvement in Scotland and effectively bringing the Auld Alliance between the two countries to a close.

1561. John Knox clashes with Mary, Queen of Scots, due to her support of the Catholic religion.

1566. David Rizzio – Mary, Queen of Scots' secretary – is stabbed to death, and Mary is held captive in Holyroodhouse Palace by Scottish nobles.

1583. Edinburgh University is founded.

1585. Plague strikes Edinburgh. One of the many occasions when plague and cholera hit the city, partly due to cramped and unsanitary conditions in the Old Town.

1603. Union of Crowns between Scotland and England. King James VI of Scotland succeeds to the English throne and leaves Edinburgh.

1632. Construction begins on the new Parliament House for the Parliament of Scotland.

1638. National Covenant signed in Greyfriars Kirkyard, designed to promote the Presbyterian Church of Scotland. Its followers were known as Covenanters.

1650. Oliver Cromwell captures the castle during the Second English Civil War and uses it as his base for his campaign to gain control over Scotland and quell a pro-Royalist uprising.

1679. Over 1,000 Covenanters are imprisoned at Greyfriars after the battle of Bothwell Brig; some are executed in Grassmarket. The Town Guard (or City Guard) is formed for prevention of crime and disorder (disbanded 1817).

1685. A statue of King Charles II is erected in Edinburgh in the year of his death.

1698. Five ships set sail from Leith on 14 July to found a Scottish colony on the Isthmus of Darien. The scheme was a huge failure, and many investors lost all of their money.

1707. Act of Union passed by the Parliament of Scotland, formerly joining the nations of Scotland and England.

1727. Royal Bank of Scotland established, setting the foundations for Edinburgh's banking and insurance industries.

1736. Porteous Riots shake the city, one of many occasions when the Edinburgh mob took events into their own hands when there was something they did not like.

1745. Charles Edward Stuart (Bonnie Prince Charlie) enters the city and proclaims his father James VIII of Scotland and James III of England. He briefly sets up residence in Holyroodhouse Palace and has a notable victory over the British army at the Battle of Prestonpans.

1759. The Nor' Loch at the foot of Edinburgh Castle is drained to accommodate the proposed New Town.

1767. Architect James Craig wins a competition for the design of the New Town.

1772. North Bridge is built as a link between the Old Town and the New Town.

1842. The railway reaches Edinburgh.

1846. The Scott Monument is erected.

1895. Edinburgh is lit by electricity.

1902. Waverley Station is completed.

1920. Along with six other suburbs, the port of Leith is merged into Edinburgh, despite very strong protests from the residents of Leith.

1928. The inaugural non-stop Flying Scotsman train journey greatly speeds up travel between Edinburgh and London.

1935-39. St. Andrew's House is built on the site of the recently demolished Calton Prison to house the Scottish Office and offices of the Secretary of State for Scotland.

1947. Edinburgh International Festival is launched, and continues to this day during August each year.

1956. Edinburgh Corporation Tramways operates for the last time on 16 November.

1996. The Stone of Destiny is returned to Scotland, from Westminster Abbey to Edinburgh Castle.

1999. The Scottish Parliament is opened by Queen Elizabeth II in the Assembly Hall on The Mound.

2004. The new Scottish Parliament Building opens at the bottom of the Royal Mile.

2008. Work begins on a new tramway.

2012. The Edinburgh Agreement is signed in Edinburgh. This was an agreement between the Scottish government and the UK government to set the terms of the Scottish independence referendum – this was held in 2014 and the country voted to stay in the United Kingdom.

2014. After years of delays, route changes, disruption for locals and spiralling costs, the new tramway opens, linking the airport and the centre of Edinburgh.

For a comprehensive look at the history of Edinburgh, try the excellent book *Edinburgh, A History of the City*, by Michael Fry, Pan Books.

From the Airport

When most of us arrive at the airport of a new city, the first thing that we want to do is to get out of it as quickly as possible, to get on with much more enjoyable things. To this end, it is useful to know where to find options for getting into the city. From Edinburgh Airport, these include trams, airport bus, taxis and car hire.

Trams

Edinburgh trams have a terminus at the airport and it is a quick, cost-effective way to get into town. The tram station is located to the left when you exit the arrivals terminal, at **what3words** ref: **successes.itself.sober**.

Tickets have to be purchased before you board a tram, and this can be done from the numerous ticket machines that are located near to the tram station. Cash, contactless payment, and chip and PIN can all be used to buy tickets. Trams operate 06:18-22:48 every day of the week (approximately every 7-15 minutes). It takes 25 minutes to get to Haymarket, and a further five minutes to get to Princes Street. Various ticketing options are available (prices correct at the time of printing): an adult single is £6.50 (child £3.30); an adult open return is £9.00 (child £4.80); and a network day ticket, which can be used on all trams and Lothian Region buses, is £10.00 for an adult (child £5.00). Multi-day network tickets can also be bought online, at **edinburghticket.co.uk**, for three, four or five days.

...cont'd

Buses

The Airlink bus is another good option for getting into the city centre. It leaves from the front of the airport terminal building, at **what3words** ref: **paid.snow.dare**. The Airlink bus takes slightly longer than the tram (approximately 40 minutes to St. Andrews Square, near Princes Street), departing every 15 minutes during the day (04:30-00:30) and every 30 minutes during the night (00:30-04:30), Monday to Sunday. Tickets can be bought onboard from the driver, using cash, contactless

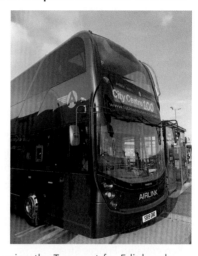

payment, or m-tickets, using the Transport for Edinburgh **TfE M-Tickets** app (available from Apple App Store or Google Play Store). Ticket prices at the time of printing are: £4.50 for an adult single (child £2.00) and £7.50 for an adult open return (child £3.00). Network day tickets (see the previous page) can also be bought on an Airlink bus.

Taxis and car hire

Taxis can be taken to the city centre, but obviously this is a more expensive option. Taxis can be hired from the ground floor of the multi-storey carpark at the front of the main terminal building at **what3words** ref: **discrepancy.swift.latter**.

Most major car hire companies operate at the airport, at **what3words** ref: **taped.finger.scope**. However, it should be noted that driving is not always the best way to get around the centre of Edinburgh, and public transport is an excellent option.

On Foot

Edinburgh is a city with a population of approximately 500,000, which means that large parts of it are ideal for seeing on foot as long as you do not mind walking up a few hilly streets. Both the Old Town and the New Town can be explored on foot, and it is the perfect way to discover some of the city's many fascinating nooks and crannies.

Edinburgh City Council understands the benefits of walking around the city, and in 2019 it published a 10-year plan to create pedestrian areas in parts of the Old Town. In 2021, these plans were developed further with a traffic-free proposal for George Street (which runs parallel with Princes Street), with the aim to turn it into a European-style boulevard, with landscaping and widened pavements. The Council is also developing low-emission policies to try to ensure the air quality in the city centre is as good as possible.

Princes Street is already largely free of general traffic, with just buses, trams and taxis allowed. This makes for a much more pleasant walking environment, but care is still required when crossing Princes Street.

Also, be prepared to be sidetracked when walking around Edinburgh: a walk along the Royal Mile, for instance, may seem straightforward enough, but there are numerous detours to be taken along the closes (lanes) that punctuate the Royal Mile on both sides, leading to courtyards, buildings or other streets.

When planning a day's sightseeing on foot in Edinburgh, some items to take include:

- A pair of good walking shoes.

- An umbrella and a light waterproof jacket that can be folded easily and carried in a bag. Despite what the weather may look like when you first set out, there is always a chance that it could change on an hourly basis!

- Water. Even in Edinburgh's temperate climate, walking around the streets can be thirsty work.

Wi-Fi in Edinburgh

Tourists expect the availability of good-quality Wi-Fi wherever they go these days, and Edinburgh is well served in this respect. Many cafés and pubs provide free Wi-Fi, and there is also free city-wide Wi-Fi available in the city centre. This is provided by IntechnologySmartCities, in partnership with the City of Edinburgh Council. The service is free, with no time restrictions, and provides fast internet access in open-air areas in the city centre (although it can be erratic at times). To use the service:

1 Turn on the **Wi-Fi** option on your smartphone, accessed in the Settings app

2 Tap on the _EdiFreeWiFi option

3 Enter some basic details to connect to the Wi-Fi service, or enter your Facebook login details on the **Log In** page if you have a Facebook account

City Transport

Edinburgh is well served by a variety of public transport options (some of which have been the object of more than a little controversy), and cyclists are also catered for with an increasing number of protected cycle lanes.

Buses

The main bus service in Edinburgh is operated by Lothian Buses, and their maroon buses are a feature all over the city. Bus stops throughout the city centre display routes and ticket options, and some of them have electronic displays showing details about the next arrivals. Tickets can be purchased with cash, contactless payment, or the Lothian Region **TfE M-Tickets** app.

Full details, including routes and timetables for buses in the city, can be found online at **lothianbuses.com**

Trams

Edinburgh has a long history of tram use in the city, dating back to the end of the 19th century when horse-drawn trams were used. At the beginning of the 21st century it was decided to reintroduce trams to Edinburgh, and construction began in 2008. However, the project was beset by problems, controversy and massive cost overruns. Despite these problems, the tram service opened in 2014. Trams run from Edinburgh Airport to near St. Andrew Square via Princes Street, and are an excellent option for getting into the city if you're arriving at the airport.

Full details about the Edinburgh tram service can be found at **edinburghtrams.com**

...cont'd

Cycling

As with many cities around the world, Edinburgh is trying to promote cycling and walking as much as possible. To this end, there is an increased number of cycle lanes in the city, and many of them are now protected from traffic with bollards along the outside of them.

Taxis

Black taxis are a familiar sight on the streets of Edinburgh. They can be hailed on the street if a yellow light on the roof is showing, or taken from taxi ranks (always go to the taxi at the head of the queue). Private hire taxis are also available, and Uber operates in the city.

Tour buses

Edinburgh offers a range of city bus tours, taking in all of the main sights of the city. Tickets can be bought on Waverley Bridge at **what3words** ref: **hits.glee.empire**, and you can then hop on and hop off as many times as you like during the day.

Weather

Even the biggest cheerleaders for Edinburgh would be hard pressed to claim that its weather is one of the main reasons for visiting the city. The word "changeable" could have been invented to describe the elements in Scotland's capital, but the Edinburgh weather should be embraced for what it is: on a sunny day it is hard to think of a better location, but you are just as likely to be met with wind or rain, or that particularly Scottish weather phenomenon, "mizzle". This is a combination of mist and drizzle, creating an enveloping blanket of moisture that seems to soak your clothes without you even noticing.

Another local weather peculiarity is known as the "Edinburgh haar". This is a sea mist that rolls in from the coast and the Firth of Forth, creating an atmospheric – if gloomy – cloak for the city. (At times, Edinburgh can be shrouded in the haar, while a few miles further inland there is glorious sunshine, much to the annoyance of the locals.)

However, one thing that the vagaries of the Edinburgh weather helps create is a sense of atmosphere. If you are on a city break, you may not have blue skies for all of your photos, but the historic city architecture lends itself to creative photos that can capture the character of the city. Although most of the photos in this book were taken in good weather, do not despair if this is not the case when you visit – try to be creative and use the weather conditions to your photographic advantage.

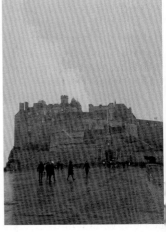

Even with the unpredictable Edinburgh weather, it is still possible to capture artistic photos, particularly in black and white.

Food and Drink

As befitting a major capital city, Edinburgh provides dining options from coffee and cake or fish and chips, to fine dining in Michelin-starred restaurants, and everything in between. Cuisine from around the world can be sampled throughout the capital, and traditional Scottish fare is also widely available. If you want to have a complete Scottish dining experience, you could have a three-course meal featuring three local favourites:

- **Cullen skink**. Virtually a meal in itself, this is a hearty fish soup made principally with smoked haddock, potatoes and onions. The name comes from the town of Cullen on the Moray Firth in the northeast of Scotland, with skink traditionally meaning shin or knuckle of beef, which was used to make several versions of soup. If this was not available, fish was used instead, but the name stuck. It is similar to chowder, and a perfect option after a long day of sightseeing.

- **Haggis, neeps and tatties**. Haggis with mashed turnip (or swede) and mashed potatoes is not only Scotland's national dish, but it is also still regularly eaten around the country. In Edinburgh restaurants you will find it with varying accompaniments (and prices), including whisky sauce or a nip of whisky, or both. Haggis also comes in other forms, including sliced haggis in a breakfast roll, or deep-fried haggis from the chip shop, which is actually a lot nicer than it sounds! Haggis can be bought from most butchers and supermarkets in the city. One of the most well-known brands is Macsweens, and their shop in Bruntsfield, at **what3words** ref: **burden.strictly.dried**, is well worth a visit. Vegetarian and vegan options are also available.

- **Cranachan**. A rich dessert that was developed to use the raspberry crop that is plentiful in Scotland from June onward. It consists of raspberries, oats, cream, honey and whisky, and is frequently served for special occasions, although it is equally delicious any day of the year.

Public Toilets

One prosaic but essential element for any successful day's sightseeing is the provision of public toilets, and if they are free then so much the better. Restaurants, pubs and cafés may allow use of their toilets in an emergency, but in general this is frowned upon. There are a number of free public toilets located in the centre of the city, including:

- **Waverley Station** – Excellent, free toilet facilities, and you don't even need to be catching a train. Entrances to Waverley Station are at Market Street, at **what3words** ref: **orchestra.plates.punch**; at Waverley Bridge, at **advice.code.only**; or at Calton Road, at **splice.hats.hood**.

- Castle Wynd North, at the top of Castlehill, 10:00-18:00, at **tolls.foster.nurses**.

- Castle Terrace, NCP car park (Ladies on second level down; Gents on third level down), 10:00-19:30. Enter the NCP carpark at **obey.online.called**.

- Princes Street Gardens Ross Bandstand (accessible toilet), 10:00-16:30, at **candle.guilty.global**.

- Princes Street Gardens West, 10:00-19:00, at **hips.wasp.leaps**, with Edinburgh Castle in the background.

- Stockbridge, Hamilton Place, 10:00-18:00, at **slurs.cherry.orders**.

3 Smartphone Photography

When you are on a city break, there are a lot more exciting things to do than worry about the settings on your smartphone camera or how you are going to capture the best photos with it. However, if you are armed with a few simple tips and tricks you will feel that you can concentrate on the photos you are going to take, rather than the smartphone camera itself.

This chapter covers some points for using your smartphone camera so that you can channel all of your attention on the subjects. This includes: mastering your camera's settings so that it is always ready for optimum use; changing the orientation to capture two different photos from the same spot; using filters for artistic effects; ensuring that you always have the correct focus and exposure for your photos; capturing several photos for the same subject, to ensure you have the best lighting; using a grid for composing elements in your photos; and ensuring that your smartphone camera is kept in the best condition possible.

Using Camera Settings

On traditional digital cameras, the various settings can be accessed from buttons or controls on the body of the camera and also from a menu that is usually viewed on the screen on the back of the camera. However, camera phones do not have this functionality on the body of the smartphone. Instead, settings can be accessed from the screen of the Camera app and also within the smartphone's Settings app. This is where a range of settings can be applied for the smartphone, including those relating to the camera. To access camera settings on a smartphone:

1 Tap on the **Settings** app

2 Tap on the **Camera** option within the Settings app

3 A range of settings can be applied for the camera, depending on the make and model of smartphone. (Other settings, such as flash and self-timer, can be accessed from the **Camera** app)

Orientation

Most of the photos in the book have been taken in Portrait mode, as it is the most effective orientation for the page format. However, one of the quickest and easiest ways to change the composition of a scene is also one of the most effective: simply turn the smartphone 90 degrees. This changes the orientation from Portrait to Landscape, or vice versa. Since it only takes a few seconds to do, it is worth considering this for most photos that you take.

- Portrait photos give more emphasis to the vertical aspect of a scene.

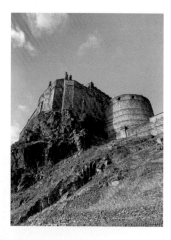

- Turn the smartphone 90 degrees to Landscape orientation, which gives more emphasis to the horizontal aspect of a scene and creates a different perspective.

Focusing and Exposure

Smartphone cameras are very adept at focusing on the scene in front of them and measuring the required exposure, known as Auto Focus (AF) and Auto Exposure (AE). However, by default they try to do this over as much of the scene as possible. On most occasions this is what is desired, but there may be times when you want to have the camera take these readings from one specific point. If this is done, the smartphone camera will still try to get the correct readings to have as much of the rest of the photo in focus as possible.

To select a specific AF and AE area in a photo:

1 Open the **Camera** app and compose a scene

2 Press and hold on the screen on the area that you want to be the main focal and exposure area

3 A coloured square appears over the selected area

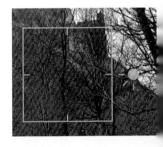

4 Keep holding on the screen until the **AE/AF LOCK** button appears at the top of the screen. This indicates that the focal point and exposure have been set where you specified, and

they will remain there once you remove your finger from the screen and move the camera

Working with Filters

Filters are artistic effects for digital photos that can give them a significantly different – and frequently artistic – appearance. Filters can be added when photos are edited using a photo-editing app, and they can also be applied when a photo is taken with a smartphone camera. If this is the case, the original photo will have a filter applied to it: if you want to capture a realistic version of a scene, take a photo of it without a filter first. Another photo using a filter can then be taken afterwards. To apply a filter when a photo is being taken:

1 Open the smartphone's **Camera** app

2 Tap on the **Filter** button

3 Tap on one of the filter options to apply it to a photo before it is taken

4 Capture the photo. The filter will be applied and will stay selected until another filter is selected or the **Filter** button is turned **Off**

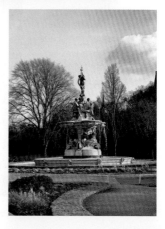

Getting on the Grid

Composition is one of the key elements of good photography; i.e. where subjects are placed in a photo. Generally, the main subject appears in the centre of a photo, but there are good artistic reasons to move the main subject to other areas of the photo. This can be done visually when composing a photo with the smartphone's Camera app. However, it is possible to make this process slightly easier by displaying a grid over the scene that is being viewed. This is a 3 x 3 grid that produces nine segments: the main subject can then be positioned within any segment (or at the intersection point between segments – see the next page) to create a more artistic composition. The grid can be displayed or hidden within the camera settings:

1 Access the camera settings as shown on page 42

2 Tap on the **Grid** option so that it is **On**

Grid	

3 When the **Camera** app is opened, the grid is superimposed over the scene being viewed (the grid does not appear in the final photo)

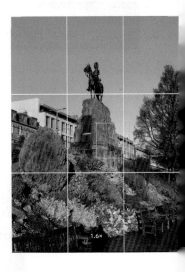

Rule of Thirds

The Rule of Thirds is a photographic composition technique that can be used to position a main subject within any of the nine segments that are created by the 3 x 3 grid, or at any of the intersection points. If you have a particularly appealing scene in front of you it is worth experimenting by taking several photos, positioning each one in a different location according to the Rule of Thirds. This can create different end results from the same location:

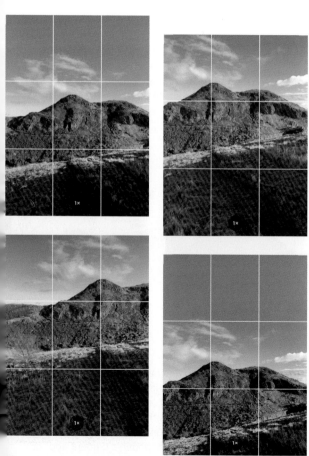

Bracketing and HDR

There are some photographic scenes that we can capture numerous times; e.g. those close to our home. However, at times there will also be locations and photographic opportunities that may be a one-off. In cases like this it is important to try to get the best shots possible in case you do not get the chance again. One way to do this is to take each shot at different exposure settings, known as "bracketing". This can be done manually by changing the exposure for different shots by pressing on the screen at different points to lock the exposure, as shown on page 44.

 Press and hold on the screen to select the exposure for a specific area of a scene, and take a photo. Press and hold at another point to alter the exposure of the scene, and take another photo. Repeat this as often as required

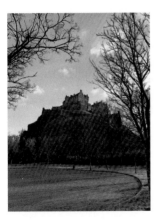 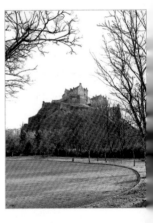

Also, some smartphone cameras can bracket photos automatically using a technique known as HDR (High Dynamic Range). This takes at least three photos at different exposures and then combines them to create one photo with the ideal exposure. HDR mode can usually be accessed from a button within the smartphone's Camera app, or within the Settings app.

Zooming In and Out

Smartphone cameras have a Zoom function so that you can make subjects appear larger on the camera's screen. However, unlike traditional cameras that use an optical zoom by changing the distance between the camera's internal lenses, digital zoom is the same as cropping a photo or zooming in on it using a photo-editing app. Digital zoom works by increasing the size of the pixels on the screen, and produces an inferior quality compared with using optical zoom. It is therefore important that zooming is not overused on smartphone cameras: the greater the amount of zoom, the greater the reduction of image quality (and the same effect can be achieved by cropping a non-zoomed photo). However, it can still be useful to use a certain degree of zoom, and there are two ways to do this:

1 Swipe inwards with thumb and forefinger to zoom out on a scene with the **Camera** app

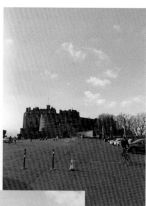

2 Swipe outwards with thumb and forefinger to zoom in on a scene with the **Camera** app

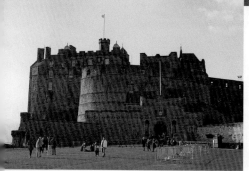

The Golden Hour

For the best photographs, the ideal natural lighting
conditions usually occur approximately one hour after sunrise
and one hour before sunset. In photographic terminology,
this is known as the Golden Hour.

The reason that the Golden Hour is so good for
photography is because of the angle at which the light
hits its subjects, and because at these times it produces
a deep glow rather than the harsh glare of midday sun.
The morning and evening Golden Hours produce slightly
different effects: the morning sun has a soft golden effect,
while the evening sun tends to have a stronger orange glow
with a bit more depth to it.

The other thing to be aware of about the Golden Hour is
that it is short. This means that you will not have a lot of
time to move from location to location. It is best to pick a
subject that you want to capture and then concentrate on a
few top-quality shots.

Going Black and White

Black and white can create very artistic photos, and can be used to develop a style that stands out against the majority of colour photos that are produced. Black and white photos can be created when a photo is taken with a smartphone camera, usually by using the appropriate filter, or in a photo-editing app once a photo has been taken. If possible, create photos in black and white when a photo is taken, as well as colour ones.

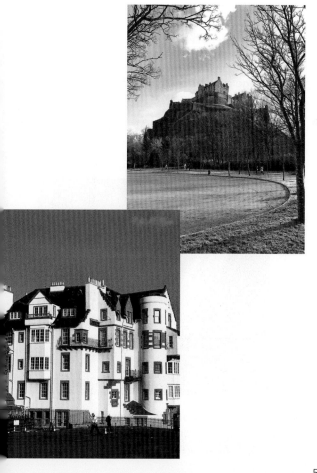

Basic Maintenance

Unlike traditional cameras, smartphone cameras generally do not have as many accessible moving parts. This means that they are less susceptible to damage through everyday irritants such as dirt and dust. However, there are still a few steps that can be followed to ensure that your smartphone's camera remains in the best condition:

- **Keep the lens clean**. If specks of dust or dirt are on the lens, these could show up in photos. Use a soft, lint-free cloth (similar to those used to clean spectacles) to clean the lens, particularly at times when you are taking an important photo.

- **Regularly inspect the lens for any physical damage such as scratches**. If the lens is scratched, this will impact all of your photos.

- **Use a phone cover that has a raised edge to protect the camera**. If the phone is dropped, the cover's edge should hopefully save the camera from any damage.

- **Avoid extremes of heat or cold**. These could affect the overall operation of the smartphone and therefore impact on the efficiency of the camera.

4 Edinburgh Top Sites Photos

Many of the top tourist sites in Edinburgh – including Edinburgh Castle, the Scott Monument, and the statue of Greyfriars Bobby – are known around the world and easily recognisable. This chapter shows you locations to capture photos of these iconic sites without having to spend several hours of your precious city break trying to track down where to take photos from.

Also covered are well-known locations in the city that may not enjoy quite the same level of fame as the better-known attractions, but are still essential to see and photograph when visiting Edinburgh. These include sites in the Old Town such as St. Giles' Cathedral, Canongate Tolbooth, Victoria Street, and Grassmarket. It also looks at sites that are slightly further afield, including the new Scottish Parliament building, Arthur's Seat, and Dean Village.

If you cover all (or most) of the photo sites in this chapter, then you will be well on your way to discovering the heart and soul of the city.

Castle with Ross Fountain

Photo spot: Edinburgh Castle with the Ross Fountain in the foreground.
what3words ref: riders.nuns.item

Direction: Facing southeast, away from Princes Street, 138°SE

Camera zoom: x1

Best time of day: Afternoon/early evening, with the sun to the right-hand side.

Additional shot: Move closer to capture a close-up of the Ross Fountain, with the detail of its figures – see the next page.

 Selfie spot: Sit on the circular wall around the Ross Fountain and try to capture a selfie of yourself, the fountain and the castle.

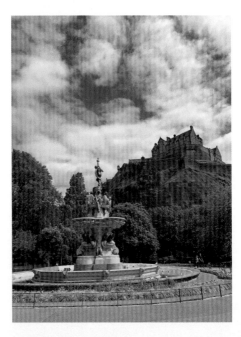

...cont'd

About this photo

Getting there: From Princes Street, at the junction of Hanover Street at **dated.pass.ripe**, walk west along Princes Street for approximately 400 metres. Before you reach the end of Princes Street, turn into Princes Street Gardens on your left-hand side, at **pizza.guard.recent**. Walk along the path to the right, towards the castle, until you reach the photo spot.

Photo fact: Created in the 19th century by the French sculptor and artist Jean-Baptiste-Jules Klagmann (1810-67), the Ross Fountain is a cast-iron structure that is decorated with a range of artistic figures – some real and some imaginary – including mermaids, walruses and cherubs. It was brought to Edinburgh in 122 separate pieces by a local gunmaker, Daniel Ross. It was officially opened in 1872, although Ross had sadly died a year earlier. In 2017, a major conservation project took place to restore the Ross Fountain to its former glory, including ensuring that the fountains worked again. The project cost £1.9 million and took approximately 40,000 hours of work. The restored fountain was unveiled in July 2018.

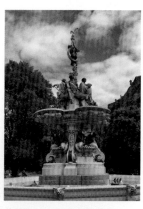

Nearby food and drink: The Pavilion Cafe Bar is located next to the Ross Fountain, and it is a good location to have refreshments while admiring the fountain and the castle.

Nearby attractions: Take some time to walk through Princes Street Gardens, to the east of the Ross Fountain.

Castle from Princes Street

Photo spot: Edinburgh Castle from Princes Street Gardens.
what3words ref: **tribal.apple.salads**

Direction: Facing southwest, towards the castle, 241°SW

Camera zoom: x2

Best time of day: Late morning, with the sun to the left-hand side.

Additional shot: Increase the zoom level of the camera to capture a shot of the houses of Ramsay Garden, below and to the left of the castle.

Selfie spot: Capture a selfie with the greenery of Princes Street Gardens behind you.

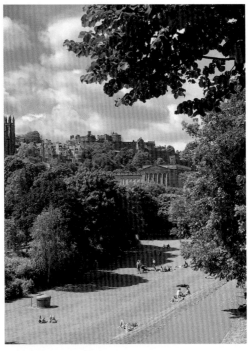

...cont'd

About this photo

Getting there: From Princes Street, at the junction of Hanover Street at **dated.pass.ripe**, walk east towards Waverley Station. Turn right along Waverley Bridge at **dust.dream.guard**. Turn into Princes Street Gardens at **shaped.forest.became**. Take the first path to your left to get to the photo spot.

Photo fact: The building that appears

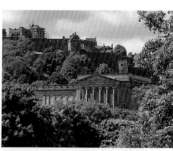

below the castle in the photo is part of the Scottish National Gallery. Built by the renowned Scottish architect William Henry Playfair, it opened in 1859 and contains an impressive collection of Scottish paintings and also works by Renaissance artists and the Impressionists. Entry is free for the Scottish National Gallery, although there are frequently additional exhibitions within it for which there is an entry fee. The entrance for the Scottish National Gallery is on the Mound at **wiped.erase.grants** – it is located next to the Royal Scottish Academy, which is a separate art gallery but one that maintains close links with the Scottish National Gallery.

Nearby food and drink: The Scottish National Gallery has its own café – The Scottish Cafe & Restaurant – that includes a terraced area with excellent views of Princes Street Gardens.

Nearby attractions: Waverley Station is a short walk from the photo spot on Waverley Bridge, and the booking office for the Royal Edinburgh Military Tattoo is a short walk past the station at the bottom of Cockburn Street, at **silly.motor.grab**. The Edinburgh Dungeon is diagonally opposite from the Tattoo booking office, on Market Street at **dizzy.dice.roses**.

Ramsay Garden

Photo spot: On Princes Street.
what3words ref: truck.spot.holly

Direction: Facing south, towards Edinburgh Castle, 175°S

Camera zoom: x3.5

Best time of day: Morning/early afternoon,
with the sun to the left.

Additional shot: Remove the zoom level (i.e. to 1:1) to
capture a shot of Ramsay Garden and the castle together.

Selfie spot: Turn left or right from the photo
spot to capture a selfie with Princes Street in the
background.

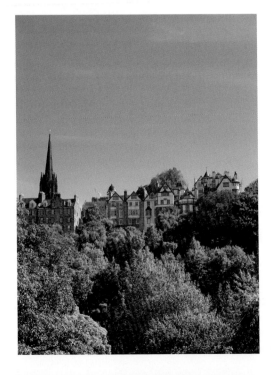

About this photo

Getting there: From Princes Street at the junction of Hanover Street at **dated.pass.ripe**, cross Princes Street to the photo spot, next to the statue of the poet Allan Ramsay, who gives his name to Ramsay Garden.

Photo fact: One of the most exclusive addresses in Edinburgh, Ramsay Garden can be seen to the left of the castle, looking from Princes Street. It can also be seen as you walk up the Mound (see Old Town Walk). There are 16 private apartments within Ramsay Gardens, some of which are valued over £1 million, although it is rare for many of them to appear on the market. The apartments overlook Princes Street and Princes Street Gardens on one side, and Edinburgh Castle and the Esplanade on the other. Ramsay Garden is named after the famous Edinburgh poet Allan Ramsay (1686-1758) who lived in Ramsay Lodge, which later became Ramsay Garden. Ramsay was known as a "makar", which is the Scots word for a poet or a bard, and his "day-job" occupation was as a wig-maker. When he retired he moved into Ramsay Lodge in 1755, which was notable for its octagonal design. Ramsay Garden was developed into its current form at the end of the 19th century by the renowned sociologist and city planner Patrick Geddes (1854-1932), who was a dedicated advocate of urban renewal.

Nearby food and drink: The entrance to Ramsay Garden is on Castlehill, at **steps.likely.scan**. If you continue up onto Castlehill, there are several establishments that provide refreshment after the steep climb.

Nearby attractions: Castlehill is home to one of Scotland's top tour companies, Timberbush Tours, at **words.legend.rounds**. They provide high-quality tours to all parts of Scotland in comfortable, air-conditioned coaches.

Floral Clock

Photo spot: At the entrance to West Princes Street Gardens, from the Mound.
what3words ref: **leans.slides.zips**

Direction: Facing north, 5°N

Camera zoom: x1

Best time of day: Afternoon, with the sun behind.

Additional shot: From the steps next to the Floral Clock is a good spot for photos of Princes Street Gardens.

Selfie spot: There is a sturdy stone banister in front of the Floral Clock, but if you can avoid this, the steps are a good spot for a selfie with this iconic Edinburgh attraction.

...cont'd

About this photo

Getting there: From Princes Street, at the junction of Hanover Street at **dated.pass.ripe**, cross to the other side of Princes Street and turn right past the Royal Scottish Academy. Cross over the Mound and enter Princes Street Gardens at **excuse.parks.trout**. The Floral Clock is on the right-hand side.

Photo fact: The Edinburgh Floral Clock was first introduced to West Princes Street Gardens in 1903 as a means to brighten up the slopes of the gardens leading down from Princes Street, and also to tell the time accurately. The first clock was inspired by John McHattie, the Parks Superintendent, and the mechanism was provided by James Richie & Sons, a local clock maker. The manual mechanism was replaced by an electric one in 1973. The Floral Clock is traditionally planted in May, and usually flowers from July to October. It takes two gardeners five weeks to plant all of the flowers for the designs each year, and 35,000 flowers are used. Since 2003 there have been summer and winter designs for the clock, and these are usually based on topical events. In the past they have celebrated the Queen's Golden Jubilee, and the centenaries of Robert Louis Stevenson and the Salvation Army. In 1953 a cuckoo clock was installed, and for many years the cuckoo appeared on the quarter hour. The Edinburgh Floral Clock was the first of its kind, and has since inspired numerous replicas around the world.

Nearby food and drink: The Mound Place at **jumpy.truth.papers**, on the opposite side of Princes Street from the **Getting there** starting point, has a variety of food trucks and ice-cream vans.

Nearby attractions: A flower's throw from the Floral Clock is the Scottish National Gallery. See page 57 for details about the gallery.

Edinburgh Castle Esplanade

Photo spot: Edinburgh Castle from the top of Castlehill. (Not accessible in August, due to the Tattoo.)
what3words ref: late.king.worker

Direction: Facing west, 250°W

Camera zoom: x1

Best time of day: Morning, with the sun behind.

Additional shot: Excellent views of Princes Street and Calton Hill can be captured from the north side of the Esplanade at **settle.learn.empty**.

Selfie spot: It's hard to resist a selfie with a castle in the background, and the Esplanade affords this opportunity. The further away you are, the more of the castle you can include.

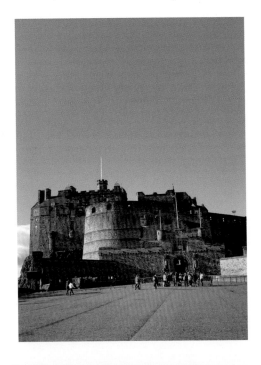

About this photo

Getting there: From Princes Street at the junction of Hanover Street at **dated.pass.ripe**, walk up the Mound, which continues to Bank Street until it reaches George IV Bridge at **likely.marker.taking**. Turn right and walk up to the castle at Castlehill.

Photo fact: Situated on Castle Rock, Edinburgh Castle is the most visited paid tourist sight in Scotland, with over two million visitors annually. Castle Rock is an extinct volcanic plug, and there has been a fortification of some sort on Castle Rock since the 11th century. Edinburgh Castle has overseen some of the most turbulent periods in Scottish history, and numerous parts have been destroyed and rebuilt – or added to – over the centuries. It has served as a royal residence and also a military garrison, and holds the record for the most besieged location in Britain. The main elements within Edinburgh Castle include: St. Margaret's Chapel, considered the oldest building in Edinburgh; the Great Hall; the One O'Clock Gun, which is fired at this time every day; the Scottish National War Museum; and Mons Meg, a huge medieval cannon. The Esplanade is also the site of the Edinburgh Military Tattoo.

Nearby food and drink: There are two tea rooms within the grounds of the castle.

Nearby attractions: On Castlehill are two more of Edinburgh's top tourist attractions. The Scotch Whisky Experience at **useful.rare.name** offers several different tour options that provide you with everything you need to know about the history of whisky and the process of making it, and a dram (or two) for tasting at the end of the tour. The Camera Obscura and World of Illusions at **pokers.deputy.emerge** contains over 100 interactive displays and activities, but the biggest draw is still the Camera Obscura itself – an innovative camera system that provides original and eye-catching views of the city.

Scott Monument

Photo spot: Scott Monument, from Princes Street Gardens.
what3words ref: crisp.pots.wiser

Direction: Facing northwest toward Princes Street, 293°NW

Camera zoom: x1

Best time of day: Morning, with the sun behind.

Additional shot: Go closer to the Scott Monument to capture some of the details on it, including statues of some famous Scottish historical figures.

 Selfie spot: This photo spot is an excellent one for a Scott Monument selfie, since as you are below the base of the monument, you can get more of it in the selfie.

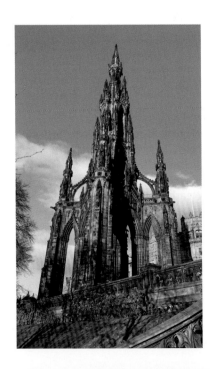

About this photo

Getting there: Cross Princes Street at the junction of Hanover Street at **dated.pass.ripe**, and enter Princes Street Gardens at **closed.sheets.rabble**. Walk east for approximately 100 metres, passing the Scott Monument on your left-hand side. Walk down the steps at **tiles.share.newest** to reach the photo spot.

Photo fact: The Scott Monument stands as a Gothic celebration of one of Scotland's greatest authors, Sir Walter Scott (1771-1832), who lived and studied in Edinburgh. He is widely credited with creating the historical novel genre, with his works such as *Waverley*, *Heart of Midlothian*, and *Rob Roy*. Such was his standing at his death in 1832, it was decided to hold a competition to design a lasting memorial. The competition was won by George Meikle Kemp, and the foundation stone was laid in 1840. Construction was completed four years later, but Kemp was not alive to see it as he had drowned when walking home on a foggy evening. Made from sandstone from a nearby quarry, the monument was inaugurated in 1846 and is adorned by dozens of statues of characters from Scott's novels and famous Scottish literary and historical figures, including Robert Burns and Mary, Queen of Scots. There are two levels of viewing platforms up to the top of the monument (total height of 61 metres) and a total of 287 steps to the top platform.

Nearby food and drink: Dishoom in nearby St. Andrew Square at **form.butter.spine** is one of the city's top Indian restaurants.

Nearby attractions: Directly to the north of the photo spot is the Livingstone Statue at **cuts.item.wider**, which commemorates David Livingstone (1813-73), the famous explorer and missionary. Although he had little connection with Edinburgh, the statue was designed by an Edinburgh sculptor, Amelia Paton Hill (1820-1904).

Walter Scott Statue

Photo spot: Princes Street.
what3words ref: dirt.tiles.eagles

Direction: Facing east, 95°E

Camera zoom: x2

Best time of day: Afternoon, with the sun behind.

Additional shot: Walk to the opposite side of the statue, or directly in front of it, to take a photo of it including Scott's loyal deerhound, Maida.

Selfie spot: Hold your smartphone below the level of your face to capture a selfie with Scott's statue behind you.

...cont'd

About this photo

Getting there: From the photo spot for the Scott Monument on pages 64-65, walk up the stairs around the monument to the west side for the photo spot.

Photo fact: When the construction of the Scott Monument was being discussed by the movers and shakers of Edinburgh society, it was decided that a mere monument was not enough – there needed to be a statue of the great man too. This reflects the high esteem in which Scott was held in the 19th century, and although his works are no longer read in large numbers, the Scott Monument and his statue remain two of the largest items created to honour a writer. The statue was designed by Sir John Steell (1804-91), a renowned Scottish sculptor from Aberdeen who also designed several other statues in Edinburgh. The statue of Scott is made from Carrara marble from Tuscany, and the white marble creates a marked contrast with the darkened sandstone of

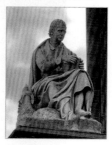

the monument. Scott is depicted holding a book, generally thought to be one of his own works, and his beloved deerhound – Maida – is resting peacefully at his feet. Scott had a great passion for dogs and owned several throughout his life. Maida was one of his favourites, as indicated by a statue of the dog that Scott had commissioned for outside Abbotsford, his family home in the Scottish Borders.

Nearby food and drink: The nearby refreshment kiosk at **dimes.sticky.logic** provides an opportunity to fortify yourself before taking on the 287 steps to the top of the monument, or to recover afterwards.

Nearby attractions: As for the Scott Monument on pages 64-65.

Balmoral Hotel

Photo spot: Princes Street.
what3words ref: **tent.artist.ticket**

Direction: Facing southeast, 115°SE

Camera zoom: x1

Best time of day: Afternoon/early evening, with the sun to the right.

Additional shot: Walk west past the hotel entrance and turn right, up South Bridge (note – at the time of printing, South Bridge is closed for extensive renovations). Walk halfway up South Bridge to get photos of Arthur's Seat and Salisbury Crags at **fear.modest.sector**.

 Selfie spot: Look along Princes Street to the east to get a shot including this world-famous thoroughfare behind you.

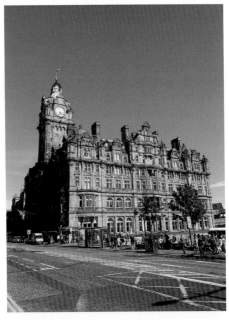

...cont'd

About this photo

Getting there: The Balmoral Hotel is located on the most easterly corner of Princes Street – the entrance is at **dare.pools.mull**. The photo spot is located on Princes Street, on the opposite side of the road.

Photo fact: The Balmoral Hotel is one of Edinburgh's iconic landmarks, and it bookends Princes Street along with the Caledonian Hotel ("The Caley") at the west end of Princes Street. Originally called The North British Station Hotel, the hotel opened in 1902 and was considered one of the great railway hotels of its generation. The hotel has changed hands a number of times over the years and has welcomed famous faces from all sectors of society, including comedy duo Laurel and Hardy, screen legends Elizabeth Taylor and Sophia Loren, musicians Paul and Linda McCartney, and British Prime Ministers Harold Wilson and Edward Heath. In

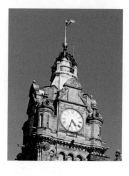

1991, the hotel reopened as the Balmoral Hotel after a three-year refurbishment costing £23 million, and it continues to attract famous faces: in 2007, J. K. Rowling completed the final *Harry Potter* book in the hotel. The clock at the top of the hotel is famously set to be three minutes fast, to help travellers going to the nearby Waverley Station get their trains on time.

Nearby food and drink: The Balmoral Hotel contains an excellent restaurant: Number One, located on the ground floor of the hotel.

Nearby attractions: For anyone looking to update their gadgets, the Apple Store is near the photo spot, opposite the hotel entrance at **proven.stores.stir**.

"Ribbon Hotel" and Balmoral Hotel

Photo spot: Top of the News Steps, above Waverley Station.
what3words ref: brain.paper.flips

Direction: Facing northeast, 42°NE

Camera zoom: x1

Best time of day: Afternoon/early evening, with the sun to the left.

Additional shot: A more detailed shot of the "Ribbon Hotel" can be taken from within the St. James Quarter at **bland.sleeps.solid** (see pages 72-73 for details). To the right of the shot there are views of Calton Hill and, to the left, Princes Street Gardens and the castle.

Selfie spot: Try to capture a selfie of yourself between the two buildings.

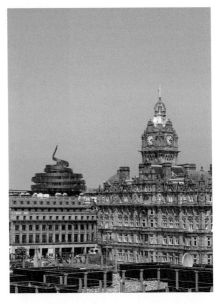

...cont'd

About this photo

Getting there: From outside Waverley Station on Waverley Bridge at **wisely.grit.frosted**, facing the castle, turn left and walk to the roundabout at the end of Waverley Bridge at **fears.fixed.chief**. Turn right up Market Street until you reach the bottom of the News Steps at **singer.simple.using**. Walk up the News Steps (124 steps to the top) for the photo of the "Ribbon Hotel" and the Balmoral Hotel.

Photo fact: The "Ribbon Hotel", as it is known locally, is one of the latest additions to the Edinburgh skyline, and presents a striking contrast with the traditional Balmoral Hotel. Officially called the W Hotel Edinburgh, it is the centrepiece of the new St. James Quarter development that opened in 2021, and houses shopping, dining and leisure facilities (see pages 72-73 for more details). The News Steps provide a link from just off the Royal Mile on St. Giles' Street to Market Street near Waverley Station. They can be considered a shortcut between the station and the Royal Mile, but probably not if you have heavy suitcases, as they are a steep climb. The name of the News Steps comes from a local newspaper and its dispatch office that was located near the top of the steps.

Nearby food and drink: On St. Giles' Street, at the top of the News Steps, is the St. Giles' Cafe & Bar for light meals or coffee and cake.

Nearby attractions: Running along St. Giles' Street is the High Court of Justiciary, with its entrance on Lawnmarket at **museum.forest.short**. It is part of Scotland's independent legal system, one of the oldest in the world.

"Ribbon Hotel" and St. James Quarter

Photo spot: St. James Square, at the St. James Quarter.
what3words ref: noises.intelligible.sooner

Direction: Facing northeast, 64°NE

Camera zoom: x1

Best time of day: Afternoon, with the sun to the right.

Additional shot: From the top of Calton Hill (see page 74).

Selfie spot: There is not a lot of space in St. James Square, so challenge yourself to capture an effective selfie with the hotel behind you (use a selfie stick and get the camera as low as possible).

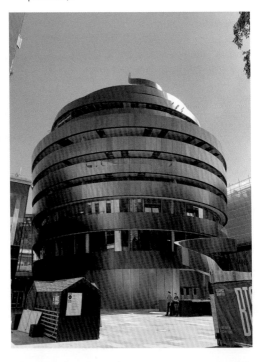

...cont'd

About this photo

Getting there: From the far east end of Princes Street, opposite the Balmoral Hotel at **wakes.bumpy.script**, walk east for approximately 50 metres until you reach the top of Leith Street at **summer.shirt.mime**. Turn left along James Craig Walk, and walk another 150 metres to the photo spot.

Photo fact: While much of the attention surrounding the St. James Quarter has centred on the "Ribbon Hotel", with strong advocates both for and against it, the rest of the St. James Quarter has provided the city with a new, modern shopping outlet, replacing what was an unloved 1970s-built eyesore. While the St. James Quarter is still just

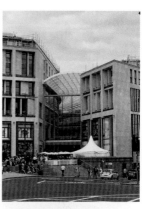

a shopping centre, it is a very spacious, bright and airy one, with several levels. It is covered by a canopy rather than a solid roof, which adds to the overall appeal of the centre, but this led to significant flooding shortly after it opened. One of the main shopping draws in the St. James Quarter is the Lego Store, which attracts queues of young and old Lego devotees.

Nearby food and drink: The St. James Quarter is home to over 30 restaurants and cafés, which offer a wide range of culinary options from hamburgers to Vietnamese street food.

Nearby attractions: Walk along Leith Street for approximately 350 metres to view St. Mary's Catholic Cathedral, which has stood there for 200 years, at **tame.basket.cattle**.

Calton Hill 1

Photo spot: Top of Calton Hill.
what3words ref: silver.cares.answer

Direction: Facing southwest towards the castle, 241°SW

Camera zoom: x1.7

Best time of day: Morning, with the sun behind.

Additional shot: Turn to the right to capture a shot of the Old Observatory House.

 Selfie spot: Use a selfie stick and turn around so that you are facing away from Princes Street to capture a selfie with this as the background.

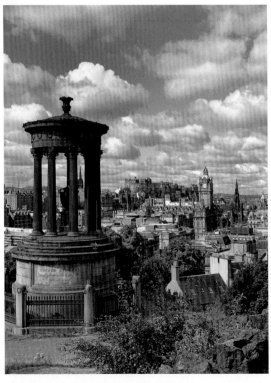

...cont'd

About this photo

Getting there: From the far east end of Princes Street, opposite the Balmoral Hotel at **wakes.bumpy.script**, cross Leith Street and walk east along Waterloo Place for approximately 275 metres until you reach the foot of Calton Hill. Walk up the path at **digit.slate.stage** to get to the photo spot.

Photo fact: Calton Hill is one of the seven hills of Edinburgh, and is located only a short walk from Princes Street. It is a popular tourist spot, and is also the location for the Beltane Fire Festival that celebrates May Day (1 May). Calton Hill not only provides stunning views of all sides of the city but also contains a number of significant buildings, including the National Monument, the Playfair Monument, the Nelson Monument, the Old Observatory House, and the Dugald Stewart Monument shown in the photo on the opposite page (the photo is equally effective by composing it with the monument to the right-hand side of the frame). This monument is a memorial to the Scottish philosopher of the same name (1753-1828), who was a professor of moral philosophy at the University of Edinburgh and a significant figure in the Scottish Enlightenment period. He was also the joint founder of the Royal Edinburgh Society.

Nearby food and drink: Along Waterloo Place, on the way to Calton Hill, are several excellent cafés and restaurants, including Howies at **drop.cake.these** and Pep & Fodder at **ofts.detect.liability**.

Nearby attractions: The Nelson Monument on Calton Hill at **design.copy.eagles** provides excellent views of Edinburgh and beyond from the top (there is an entrance fee). At the top of the monument is a large time ball (installed in 1852), which is lowered at 13:00 each day to coincide with the firing of the One O'Clock Gun from Edinburgh Castle.

Calton Hill 2

Photo spot: Top of Calton Hill.
what3words ref: **twin.magma.proper**

Direction: Facing west along Princes Street, 253°W

Camera zoom: x2

Best time of day: Morning, with the sun behind.

Additional shot: Go to **nests.rice.chip** to get an excellent shot of the "Ribbon Hotel".

Selfie spot: Try capturing a selfie while sitting on top of the cannon.

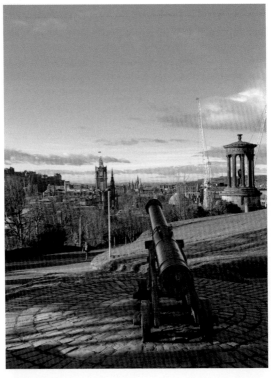

...cont'd

About this photo

Getting there: From the photo spot for Calton Hill 1, walk approximately 75 metres east to this photo spot.

Photo fact: The cannon in the foreground of the photo is known as the Portuguese Cannon. It originated in Portugal during a period of Spanish rule and saw active service in the Portuguese colonies, from Mozambique to Macao. It was then acquired by the rulers of modern-day Burma/ Myanmar. After the region was captured by British forces, the cannon was taken to Edinburgh where it was exhibited at the Edinburgh Fair of 1886 and then moved to its current location overlooking the city from Calton Hill. The cannon bears the coat

of arms of the Spanish royal family and also a Burmese inscription, testifying to its colourful history.

Nearby food and drink: Calton Hill has one café that serves snacks, coffee and cake: The Kiosk at **stands.shin.found**; and another: The Lookout at **curve.title.admire**, which provides more substantial meals.

Nearby attractions: The Playfair Monument at **maybe.diary.paths** was designed by the famous Edinburgh architect William Henry Playfair (1790-1857; see National Monument on pages 78-79) for his uncle, John Playfair (1748-1819), who was a renowned mathematician and philosopher, and was also the first President of the Astronomical Institution of Edinburgh.

National Monument

Photo spot: Top of Calton Hill.
what3words ref: post.spite.waving

Direction: Facing northwest, 313°NW

Camera zoom: x1.5

Best time of day: Morning, with the sun behind.

Additional shot: Move around the monument to capture different perspectives, including straight-on.

Selfie spot: Who wouldn't want a selfie with Edinburgh's Disgrace?

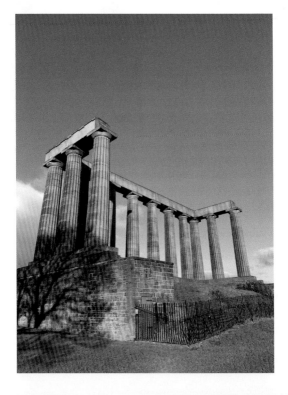

...cont'd

About this photo

Getting there: From the photo spot for Calton Hill 2 (see page 76), walk approximately 75 metres to get to the National Monument.

Photo fact: Although its official name is the National Monument, a more common local name for this structure is "Edinburgh's Disgrace", as it stands as a reminder of financial optimism over reality. Promoted as a memorial to Scottish soldiers and sailors who fell in the Napoleonic Wars (1803-15), it was designed by one of the most famous architects of the day, William Henry Playfair, to mirror the Parthenon in Athens (in keeping with Edinburgh's unofficial title as "the Athens of the North"). In addition to the National Monument, Playfair had a major impact on the architecture of Edinburgh, contributing to much of the design of the New Town, and designed numerous other famous Edinburgh buildings including the Old College of the University of Edinburgh, the National Gallery of Edinburgh, and Surgeons' Hall. Despite having several famous supporters including Walter Scott, funds for the monument dried up after only 12 columns had been erected, and work came to a halt. This was, perhaps, not a surprise, since when work on the monument started in 1826, only a third of the required funding was in place. Despite attempts over the years to complete the monument, it remains in its truncated state and, in many ways, this is now one of its biggest assets.

Nearby food and drink: As for Calton Hill 2 on pages 76-77, or it makes an excellent spot for a picnic overlooking the city.

Nearby attractions: From the National Monument, carry on back along the path and down to the bottom of Calton Hill. Turn right along Regent Road until you reach the Old Royal High School at **treat.minds.stick** (see pages 80-81 for details).

Old Royal High School

Photo spot: Regent Road, at the bottom of Calton Hill.
what3words ref: snack.chart.reduce

Direction: Facing northwest, 305°NW

Camera zoom: x2

Best time of day: Afternoon, with the sun behind.

Additional shot: Continue along Regent Road for a photo of the Burns Monument – see the next page.

Selfie spot: Facing the Old Royal High School building, take a selfie with the cityscape of Edinburgh behind you.

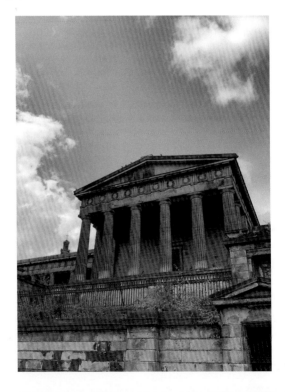

...cont'd

About this photo

Getting there: From the entrance to Calton Hill at **digit.slate.stage**, continue east along Regent Road for 300 metres to the photo spot.

Photo fact: The Old Royal High School building has served many purposes during its history, and also narrowly missed being elevated to greater heights as the country's parliament building. The Royal High School of Edinburgh is one of the oldest schools in Europe and has occupied several different locations within the city. It has had many notable pupils over the years, with two of the most famous being Sir Walter Scott and Alexander Graham Bell. The Old Royal High School building sits at the bottom of Calton Hill and was built between 1826 and 1829 in the Greek revivalist neoclassical style by the architect Thomas Hamilton (1784-1858). The Royal High School moved to a new location in the west of the city in 1968, after which the building was adapted to house a potentially devolved Scottish parliament, hence its alternative name of New Parliament House. However, it was not until 1999 that Scottish devolution was introduced, by which time it was decided to commission a purpose-built building for the new parliament (see pages 92-93). Since then, various uses have been put forward for the building, and in 2021 a proposal for converting it into a hotel fell through.

Nearby food and drink: As for Calton Hill 2 on pages 76-77.

Nearby attractions: From the Old Royal High School building, continue east along Regent Road for approximately 100 metres until you reach the Burns Monument at **strict.souk.twin**, also designed by Thomas Hamilton.

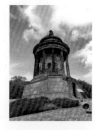

Victoria Street

Photo spot: From Grassmarket to George IV Bridge.
what3words ref: gaps.proven.react

Direction: Facing northeast, away from Grassmarket, 49°NE

Camera zoom: x1.3

Best time of day: Afternoon/early evening, with the sun to the right-hand side.

Additional shot: Walk to the top of Victoria Street and take a shot looking down the street with the colourful shop fronts on the right-hand side.

Selfie spot: If you stand at either side of Victoria Street, you should be able to get a selfie with most of the street in the shot.

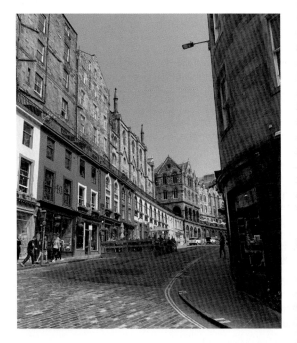

...cont'd

About this photo

Getting there: From the junction with the Mound (Bank Street) and George IV Bridge at **likely.marker.taking**, walk along the right-hand side of George IV Bridge for approximately 50 metres until you reach the top of Victoria Street at **impact.needed.scarf**. Walk along Victoria Street until you reach the photo spot.

Photo fact: Victoria Street links George IV Bridge and Grassmarket, and it is one of the most charming and aesthetically appealing streets in the city. Incorporating Edinburgh's past, when the high-rise tenements led to jostling, boisterous living conditions on many levels, Victoria Street houses numerous specialised independent

shops that appear tucked away from the street. Browsing these, you will be able to find delights ranging from modern jewellery to kilts, cheese and whisky. Victoria Street was built between 1829 and 1834, with a view to opening up the cluttered Old Town and providing better access around the city. Many of the shops on Victoria Street have colourful exteriors, resulting in numerous photos being distributed on social media. There is also a terrace that runs along the top of the shops on the left-hand side when you are looking up Victoria Street, which is not only excellent for taking photos but also has outdoor restaurant seating. It has been suggested that Victoria Street was also the model for Diagon Alley in the *Harry Potter* books.

Nearby food and drink: Try the Bow Bar at **system.necks.blaze** for a high-quality traditional Scottish pub.

Nearby attractions: The National Library of Scotland is located on George IV Bridge, opposite the top of Victoria Street.

Grassmarket

Photo spot: Grassmarket.
what3words ref: **chefs.stiff.corn**

Direction: Facing northwest, towards the castle,
315°NW

Camera zoom: x1

Best time of day: Afternoon, with the sun to the left.

Additional shot: Walk along the left-hand side of
Grassmarket to get to The Vennel at **peanut.nail.calms** –
see pages 106-107 for photo details.

 Selfie spot: Walk to the bottom of Grassmarket
to take a selfie including Edinburgh Castle at
index.rent.jumpy.

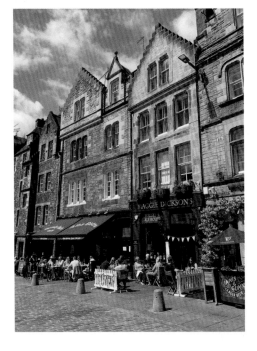

...cont'd

About this photo

Getting there: From Victoria Street, head to the bottom where Grassmarket starts at **cove.pirate.transmitted**.

Photo fact: Now very much favoured by tourists and students, the Grassmarket area has had a varied and, at times, very dark history. It has been a market area for hundreds of years, when Edinburgh had specialised markets for different products ranging from fruit and vegetables to fish.

The Grassmarket was primarily for the sale of cattle and horses, with the name deriving from the feed that was stored there for them. During the 17th century, the Grassmarket area became the sight of public executions (including the supporters of the Covenanter movement, who sought to promote the Presbyterian religion in Scotland). Hundreds of people were executed in the Grassmarket area over a hundred-year period, with one of the most famous being Maggie Dickson, who survived the hangman's noose in 1724 when she woke after her hanging. She is remembered today with an eponymous pub in the Grassmarket. The Grassmarket area also claims some of the oldest and most haunted pubs in the city, and its pedestrianisation has resulted in a plethora of outdoor drinking and dining areas.

Nearby food and drink: Almost every second establishment in Grassmarket is a pub, restaurant or café. Two of the oldest in the city are the Beehive and the White Hart Inn.

Nearby attractions: The Last Drop pub at **abode.ashes.hooks** is located in the area of Grassmarket where public executions took place.

Greyfriars Bobby Statue

Photo spot: Greyfriars Bobby statue, George IV Bridge.
what3words ref: cone.oldest.like

Direction: Facing west, looking down Candlemaker Row,
292W

Camera zoom: x2

Best time of day: Any, although try early in the morning or
later in the afternoon to avoid the crowds.

Additional shot: Turn around to capture a photo of the
National Museum of Scotland.

 Selfie spot: If you can make your way through
the crowds that usually congregate around
Bobby, this is a good spot to get a selfie with
Edinburgh's favourite canine.

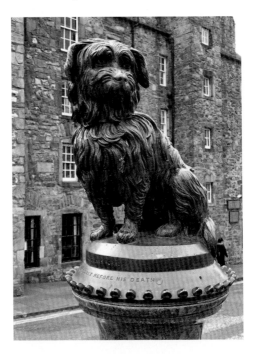

...cont'd

About this photo

Getting there: From the junction with the Mound (Bank Street) and George IV Bridge at **likely.marker.taking**, walk along the right-hand side of George IV Bridge for approximately 300 metres until you reach the statue on the right-hand side.

Photo fact: Famous around the world, Greyfriars Bobby is the epitome of a pet's dedication and devotion to its master. Bobby was a Skye terrier who lived in Edinburgh in the 19th century with his owner John Gray. When John died in 1858, Bobby spent the next 14 years sitting by his grave in the Greyfriars Kirkyard until his own death in 1872. Bobby is buried next to his beloved owner at **fumes.finest.asserts**. The Greyfriars Bobby statue was erected in front of the entrance to Greyfriars Kirkyard in 1873, and it is Edinburgh's smallest listed building. A recent tradition has grown of rubbing Bobby's nose for good luck, accounting for its worn appearance. Over the years there have been some doubts raised about certain aspects of the Greyfriars Bobby story, but it remains an enduring part of Edinburgh's animal history.

Nearby food and drink: For a taste of the Mediterranean, walk north along George IV Bridge (towards Princes Street) until you reach Cafe Andaluz at **less.cracks.stage**, for a fine range of Spanish tapas. Just before this is The Elephant House, known as "the birthplace of *Harry Potter*" (see page 160), at **forum.beast.rival** (although at the time of printing it is currently closed due to fire damage).

Nearby attractions: The National Museum of Scotland is on the other side of the road from Greyfriars Bobby, on Chambers Street – entrances at **scouts.orders.agent** and **bunk.skin.grain**.

St. Giles' Cathedral

Photo spot: St. Giles' Cathedral on High Street.
what3words ref: value.shells.nuns

Direction: Facing east, looking down the Royal Mile, 111°E

Camera zoom: x1

Best time of day: Afternoon/early evening, with the sun to the right-hand side.

Additional shot: Walk around St. Giles' Cathedral to capture the Mercat Cross on its east side at **spit.music.hung**.

Selfie spot: Capture a selfie with the statue of Adam Smith, the father of economics, on the far side (east side) of St. Giles' Cathedral.

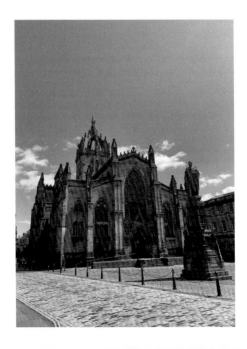

...cont'd

About this photo

Getting there: From the junction with the Mound (Bank Street) and George IV Bridge at **doing.exams.poppy**, turn left onto Lawnmarket. Continue for approximately 50 metres until you reach the photo spot.

Photo fact: Also known as St. Giles' Kirk, St. Giles' Cathedral has been a place of worship in Edinburgh for nearly 1,000 years. Edinburgh's history is closely intertwined with religion, which has contributed to the shaping of the city and overseen some of its most tumultuous times. St. Giles' Cathedral was founded by King David I in 1124 and has had a colourful history, including being used as the centre of both Catholic and Protestant worship and political power. One of the most famous figures connected with St. Giles' Cathedral is John Knox (c 1513-72), who embraced the Reformation in Scotland and brought Presbyterianism to the country. He preached at St. Giles' Cathedral and ultimately became a minister there. The Mercat Cross is located at the east side of St. Giles' Cathedral and marks the spot of the city's old market square. A unicorn sits on top of the Mercat Cross, recognizing its position as Scotland's national animal.

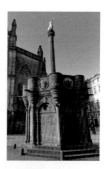

Nearby food and drink: The Royal Mile is one of the main tourist areas of Edinburgh, with dozens of pubs, restaurants and cafés. For whisky lovers, the Royal Mile Whiskies shop at **famed. lush.locked** offers an extensive range of whisky.

Nearby attractions: The Real Mary King's Close at **cooks.broke.tolls** provides tours about Edinburgh's historical past and some of its more gruesome events.

Canongate Tolbooth

Photo spot: Towards the bottom of the Royal Mile.
what3words ref: drips.bridge.soaks

Direction: Facing northwest, 300°NW

Camera zoom: x1

Best time of day: Morning, with the sun behind.

Additional shot: Just past Canongate Tolbooth facing east is a statue of Robert Fergusson (1750-74), a famous Scottish poet of the Scottish Enlightenment period who is thought to have influenced Robert Burns.

 Selfie spot: Capture a selfie with the Canongate Tolbooth clock in the background – one of its most notable features.

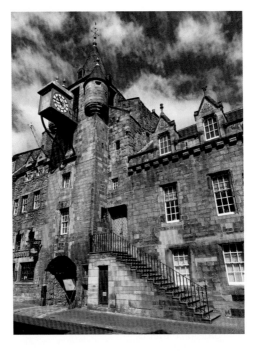

...cont'd

About this photo

Getting there: From St. Giles' Cathedral (see pages 88-89), continue along the Royal Mile for approximately 750 metres, as Lawnmarket becomes High Street and then Canongate (all elements of the Royal Mile), until you reach the photo spot on the left-hand side.

Photo fact: Tolbooths in Scottish history have generally served as public buildings, and Canongate Tolbooth was no different. Built in 1591 when Canongate was a separate burgh from Edinburgh, the Tolbooth served many purposes, including being a centre for the town council, a courthouse and a jail. The jail was mainly for people who had performed minor offences such as accruing debts, but during the 17th century it held many Covenanters – supporters of the Presbyterian religious movement who were persecuted at this time. However, the Tolbooth became famous for the number of escapes from its jail, and more than one of its jailers were imprisoned themselves for their roles in the escapes. When Canongate was incorporated into the City of Edinburgh in 1856, the role of the Tolbooth diminished, and today it houses The People's Story Museum, which tells the history of the people of Edinburgh over the centuries. The museum includes a reconstructed jail cell so that visitors can envisage how prisoners planned and conducted their escape attempts.

Nearby food and drink: For those with a sweet tooth, the Fudge House of Edinburgh is located shortly before Canongate Tolbooth, on the way down the Royal Mile at shuts.sizes.stocks, providing 27 differently flavoured varieties of fudge.

Nearby attractions: The Canongate Kirkyard (graveyard) next to the Tolbooth contains the graves of several notable Edinburgh citizens, including the economist Adam Smith and the poet Robert Fergusson (see the previous page).

Scottish Parliament

Photo spot: At the bottom of the Royal Mile.
what3words ref: radar.gaps.same

Direction: Facing northwest, away from Arthur's Seat,
307°NW

Camera zoom: x1.3

Best time of day: Morning, with the sun behind.

Additional shot: Due to its unique design, the Scottish Parliament building offers excellent options for interesting photos of the detail of the building.

 Selfie spot: Try getting a selfie with the reflection of the Scottish Parliament building in the water next to the front courtyard.

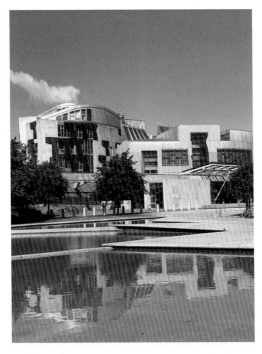

...cont'd

About this photo

Getting there: From Canongate Tolbooth (see pages 90-91), continue to the bottom of the Royal Mile for approximately 500 metres, turning onto Horse Wynd, until you get to the photo spot at Holyrood, opposite Holyroodhouse Palace.

Photo fact: One of Edinburgh's most controversial buildings, the Scottish Parliament building is a physical manifestation of the Scottish Parliament that was created as a result of the devolution referendum that was held in 1997. The Scottish Parliament legislates over certain areas of domestic policy, such as health and education. Following the devolution referendum, Donald Dewar became the first First Minister of Scotland, and a search for a new Scottish Parliament building began. Three locations were considered, including the former Royal High School at the foot of Calton Hill (see pages 80-81), with the Holyrood site eventually being selected. From the beginning there was controversy surrounding almost every aspect of the project: from its post-modern design by the Spanish architect Enric Miralles (who sadly never lived to see its completion), to its site (many locals thought it was incongruous with its Old Town location), to its cost, which overran by hundreds of millions of pounds. However, despite the criticisms, the building is undoubtedly a striking feature in the city, and since it opened in 2004 it has won several architecture prizes. The Scottish Parliament building houses the country's 129 Members of the Scottish Parliament (MSPs) and is open to the public.

Nearby food and drink: Located inside the Scottish Parliament building, the Parliament Café offers the chance to spot local politicians while having refreshment.

Nearby attractions: Holyroodhouse Palace is just a short walk from the Scottish Parliament and offers a very different perspective on Scottish history (see pages 94 95).

Holyroodhouse Palace

Photo spot: From the path heading up Arthur's Seat.
what3words ref: **flame.wake.sailor**

Direction: Facing northwest, away from Arthur's Seat,
310°NW

Camera zoom: x2.7

Best time of day: Mid-morning, with the sun behind.

Additional shot: Go into the grounds of the palace (there is an entrance fee) to get a close-up from the courtyard, at **camp.market.finishing**.

 Selfie spot: The photo spot is a good place to get a selfie with the whole of Holyroodhouse Palace in the background.

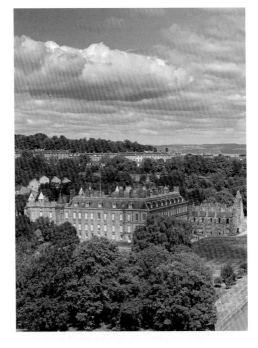

...cont'd

About this photo

Getting there: From the entrance to Holyroodhouse Palace at **brains.glare.traps**, walk along Horse Wynd, which becomes Queen's Drive, with the palace on your left-hand side. At the roundabout at **farmer.rooms.divisions**, cross the road and continue east along Queen's Drive for approximately 100 metres until you reach a path marked for the summit of Arthur's Seat at **visa.ever.rider**. Walk approximately 300 metres along the path and turn right at **scores.cheer.aura**. Continue for approximately 200 metres to reach the photo spot.

Photo fact: Holyroodhouse Palace (or the Palace of Holyroodhouse) is the royal residence in Edinburgh and provides a regal completion of the Royal Mile at the opposite end to Edinburgh Castle. Thought to have been founded by King David I in the 12th century, it has been the residence of royal figures including Mary, Queen of Scots and James VI of Scotland (who later also became James I of England), and it was also a seat of parliament for the country. It suffered during the Scottish Reformation, led by John Knox in the 16th century, but has endured over the centuries, encountering political upheaval and military attacks, including a brief stay by Bonnie Prince Charlie during the Jacobite uprising of 1745. The interior and exterior of the building have been developed considerably over the years. Today, the public can visit certain parts of Holyroodhouse Palace and also enjoy its impressive gardens. A Royal Garden Party is also held each year for specially invited guests.

Nearby food and drink: The Royal Mile is the best nearest option for restaurants and cafés.

Nearby attractions: The Dynamic Earth science attraction is a short walk from Holyroodhouse Palace – see pages 96-97.

Dynamic Earth

Photo spot: Next to the Scottish Parliament.
what3words ref: lots.again.cheer

Direction: Facing southeast, looking towards Arthur's Seat, 118°SE

Camera zoom: x1.5

Best time of day: Morning, with the sun to the left.

Additional shot: By walking up the path toward the summit of Arthur's Seat (see Holyroodhouse Palace on pages 94-95), you can capture a photo of the structure that creates the roof of Dynamic Earth.

Selfie spot: The steps in front of Dynamic Earth are a good spot to capture a selfie with the roof in the background.

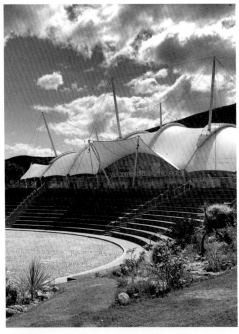

...cont'd

About this photo

Getting there: Dynamic Earth is located next to the Scottish Parliament building: walk west for approximately 150 metres from the photo spot for the Scottish Parliament (see pages 92-93) to get to the Dynamic Earth photo spot.

Photo fact: Dynamic Earth opened in 1999 and is a visitor attraction that details the scientific development of planet Earth. One of its main features, however, is the roof structure that covers the Dynamic Earth building. The Dynamic Earth exhibit traces the history of Earth, from the Big Bang to the present day. There are several interactive exhibits, and you get the chance to travel back in time in a spaceship and plunge to the depths of the ocean in a submarine. There is also a state-of-the-art, 360-degree planetarium. Dynamic Earth provides a fascinating insight into how Earth developed into what it is today, and can be enjoyed by all ages. Dynamic Earth is within easy reach of Arthur's Seat and Salisbury Crags, which can be walked along in good weather.

Nearby food and drink: The Food Chain Café is located within Dynamic Earth, for those who want to take a break from its attractions.

Nearby attractions: Dynamic Earth is within easy distance of the Arthur's Seat Walk, starting at **visa.ever.rider**. See Chapter 11 for details.

Arthur's Seat

Photo spot: Duddingston Low Road.
what3words ref: melt.wipes.flame

Direction: Facing northeast, 65°NE

Camera zoom: x1

Best time of day: Afternoon/early evening, with the sun behind.

Additional shot: Walk towards Arthur's Seat to capture a shot of Salisbury Crags to the left, at **snows.number.tiger**.

 Selfie spot: If you lie down on the grass in the photo, you can capture most of Arthur's Seat above you.

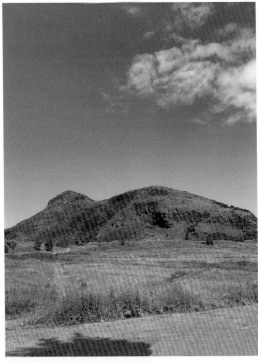

...cont'd

About this photo

Getting there: From the junction of North Bridge and High Street at **object.inspector.throw**, walk approximately 1,500 metres until you reach Salisbury Road on the left-hand side at **pencil.parts.petty** (Lothian Region buses also go along this route). Walk to the end of Salisbury Road and turn left at the top. Cross the road and take the next road on the right-hand side (Holyrood Park Road) at **tone.limes.prom**. Walk 300 metres to the bottom of the road to reach the photo spot on Duddingston Low Road.

Photo fact: Arthur's Seat is synonymous with Edinburgh and can be seen from most areas of the city. It is an extinct volcano that sits in Holyrood Park, and all parts of the city can be seen from its summit, which stands at 251 metres (823 feet). The origin of Arthur's Seat's name has been hotly debated over the years, with popular opinions being that it was named after King Arthur or from the corruption of various Gaelic names. Arthur's Seat and the adjoining Salisbury Crags are where the famous Scottish geologist James Hutton (1726-97) did much of his research, studying their rock formations. Hutton is known as the "father of geology", and his work helped determine that Earth's crust was not formed at one particular point in time, but rather developed as a natural process over an extended period of time. There are several different walks that can be taken to the summit of Arthur's Seat – see Arthur's Seat Walk (Chapter 11) for details about walking to the summit.

Nearby food and drink: The best way to keep refreshed while walking up Arthur's Seat is to take your own supplies. At least, make sure that you have water when climbing to the summit.

Nearby attractions: Continue approximately 1.5 kilometres along Duddingston Low Road to get to the picturesque village of Duddingston.

Dean Village

Photo spot: Dean Village, by the Water of Leith.
what3words ref: brush.oldest.neck

Direction: Facing northeast, 60°NE

Camera zoom: x1

Best time of day: Afternoon/early evening, with the sun to the right or behind.

Additional shot: Take a photo of the striking yellow house (Hawthorn Buildings) to the right of the photo spot.

Selfie spot: Stand on the bridge at the photo spot to take a selfie that includes the buildings and the Water of Leith.

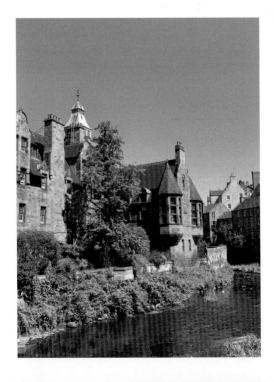

...cont'd

About this photo

Getting there: Dean Village is only about a 15-minute walk from the centre of the city. From the far-west end of Princes Street at **chops.admit.shows**, turn right onto Queensferry Street, heading north. Continue along Queensferry Street (which becomes Drumsheugh Place and then Lynedoch Place) for approximately 400 metres until you meet Bells Brae on the left-hand side at **goes.save.fruit**. Walk along Bells Brae for approximately 150 metres until you reach a four-way junction at **voices.woke.tries**. Turn left along Hawthornbank Lane and walk approximately 125 metres to get to the photo spot.

Photo fact: Dean Village is one of the most picturesque and tranquil areas of the city, located on the Water of Leith (see pages 190-200 for details about the Water of Leith Walk). It was constructed during the 1880s and designed as a suburb for milling workers who worked at the local water mills. Dean Village was originally slightly separated from the rest of the city, and it still retains a strong sense of its own unique identity. The main building in Dean Village is the Well Court (to the left in the photo), and this was where many of the mill workers lived. The imposing Dean Bridge that overlooks Dean Village was designed by the acclaimed Scottish civil engineer, Thomas Telford (1757-1834), and was used to connect the two sides of the valley in which Dean Village is located.

Nearby food and drink: There are no places for refreshment in Dean Village itself, but there are numerous options on Queensferry Street on the way to Dean Village.

Nearby attractions: The Gallery of Modern Art can be walked to from a path that is reached by crossing the bridge at the photo spot and turning to the left at **long.soft.rents**.

The Three Bridges

Photo spot: Port Edgar Marina, South Queensferry.
what3words ref: reviewed.greed.pampered

Direction: Facing north, 14°N

Camera zoom: x1

Best time of day: Afternoon/early evening, with the sun to left.

Additional shot:
There are numerous opportunities for taking photos of the individual bridges, from along Shore Road or High Street in South Queensferry.

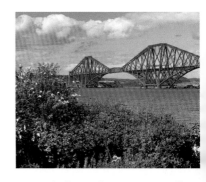

 Selfie spot: As a challenge for an expert selfie-taker, try taking a selfie with all three bridges.

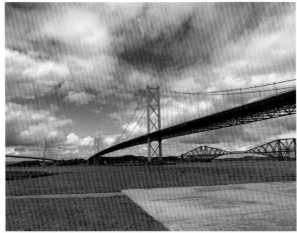

...cont'd

About this photo

Getting there: South Queensferry is 10 miles from Waverley Station, and trains can be taken to Dalmeny (which serves South Queensferry). From the station, walk into the centre of town and follow High Street west until you reach the photo spot (approximately 2,500 metres in total).

Photo fact: The three bridges are – from left to right in the photo – the Queensferry Crossing, the Forth Road Bridge, and the Forth Bridge. They all provide a link across the Firth of Forth between Queensferry (in West Lothian, on the south side of the Forth) and North Queensferry (in Fife, on the north side of the Forth). The Forth Bridge is the oldest of the three, and is a cantilever rail bridge that was opened in 1890 and has become an iconic Scottish image. It is frequently referred to as the Forth Rail Bridge – although this is not its official name – and is used mainly to distinguish it from the neighbouring Forth Road Bridge that was opened in 1964. At the beginning of the 21st century it was clear that the Forth Road Bridge was showing its age, and in 2007 it was decided that a replacement was required. This opened in 2017, and was named the Queensferry Crossing after a public consultation. It is the largest bridge of its kind in the world (three-tower, cable-stayed), and includes wind shields to protect against the fierce winds that can blow up the Firth of Forth. However, it has been prone to ice falling from its towers, and twice had to be closed for short periods during 2020 due to falling ice.

Nearby food and drink: The High Street in South Queensferry has a number of excellent cafés, restaurants and pubs, some offering views of the bridges.

Nearby attractions: Boat tours can be taken from South Queensferry, from the Hawes Pier at **burden.strictly.dried**. The tours take in the Firth of Forth and its wildlife, and also the nearby Inchcolm Island.

Top Sites Details

After taking photos of any top city sights, it is worth taking a few extra minutes to see if there are any more photographic opportunities to be had. This is particularly effective if you concentrate on the details of buildings. Some options around the city include:

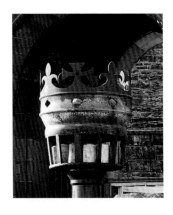

The large crown-shaped metal torches at the entrance to Edinburgh Castle.

One of the 68 statues that adorn the Scott Monument.

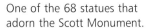

The modern architecture of the Scottish Parliament building, such as its windows and doors.

5 Hidden Edinburgh Photos

While many of the main sights of Edinburgh are iconic and well recognised, there are also a number of locations that offer excellent photographic opportunities, but they are not as well known as sights such as Edinburgh Castle or the Scott Monument.

Some photo locations, such as The Vennel or the Heart of Midlothian, are hidden in plain sight and you just need to know where to the look. Others, such as Jacob's Ladder, are genuinely harder to find and they need a bit of searching out. However, when you do find them, you will be rewarded with photo spots ranging from the Princes Street Gardens Gardener's Cottage to the picturesque North West Circus Place.

This chapter delves into some fascinating nooks and crannies that are often overlooked by the majority of visitors to the city.

The Vennel

Photo spot: Off Grassmarket.
what3words ref: wipe.judges.return

Direction: Facing northwest, towards the castle, 332°NW

Camera zoom: x1.3

Best time of day: Early afternoon, with the sun behind.

Additional shot: At the top of The Vennel is part of the old Flodden Wall, which was once part of the city's defences (see the next page).

Selfie spot: The Vennel is an excellent spot to capture an atmospheric selfie at dusk with Edinburgh Castle in the background.

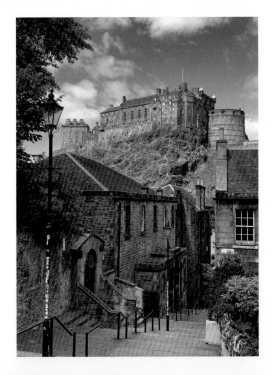

...cont'd

About this photo

Getting there: From the bottom of Victoria Street, walk along the south side of Grassmarket until you reach the bottom of The Vennel steps at **vibes.vibes.snake**. Walk up the steps to the photo spot.

Photo fact: Located off Grassmarket, The Vennel is one of numerous collections of alleys, steps and pathways that link various parts of the city. From about halfway up the steps is an ideal point to capture one of the best views of Edinburgh Castle. The name for The Vennel comes from the French word "venelle", which means a small or narrow street. A remaining part of the Flodden Wall is located at the top of The Vennel, in the Greyfriars Kirkyard. It was built in the 16th century as protection against attack from England, following the English victory at the Battle of Flodden in 1513.

Nearby food and drink: From the bottom of The Vennel, cross to the far side of Grassmarket to find the pizza restaurant Mamma's American Pizza at **lock.fits.beats**. Opened in the 1980s, Mamma's claim to fame is that one of its original founders was an American actor who appeared in the *Star Wars* film (although it is now under different ownership).

Nearby attractions: Walk down The Vennel and turn left to explore the West Port – the area frequented by Burke and Hare, the murderers often thought of as grave-robbers (see page 178).

Ramsay Garden

Photo spot: Off Ramsay Lane, near Castlehill.
what3words ref: keeps.deflection.noble

Direction: Facing west, 291°W

Camera zoom: x1.3

Best time of day: Late morning, with the sun behind.

Additional shot: Walk into Ramsay Garden (which is a cul-de-sac) to get photos of the whitewashed flats with red details at the end of the cul-de-sac.

Selfie spot: Selfies can be taken in front of the coloured doors, but make sure you are not inconveniencing any of the occupants.

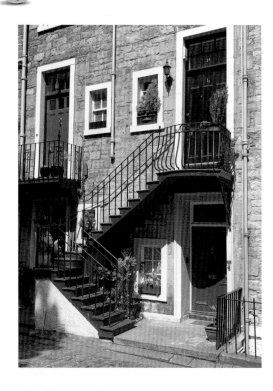

...cont'd

About this photo

Getting there: From Princes Street, at the junction of Hanover Street at **dated.pass.ripe**, walk up the Mound and turn right onto Mound Place at **shave.serve.itself**. Continue along Mound Place for approximately 125 metres until it becomes Ramsay Lane at the photo spot.

Photo fact: While the front of Ramsay Garden is a popular photo spot from Princes Street (see pages 58-59), the side facing away from Princes Street (which is technically the front of the flats) is equally picturesque and photogenic, featuring coloured doorways and outdoor staircases. Ramsay Garden was designed by one of the most renowned town planners of his age, Patrick Geddes (1854-1932), and is one of Edinburgh's most exclusive addresses, although it can be noisy there during August when the Edinburgh Military Tattoo takes place on Castle Esplanade, just a few metres away.

Nearby food and drink: If you continue up onto Castlehill, there are several establishments that provide refreshments near the castle.

Nearby attractions:
On the way up Mound Place on the way to Ramsay Garden, you pass the imposing New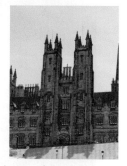
College presiding over the top of the Mound. New College is part of the University of Edinburgh, and houses the university's School of Divinity and also the General Assembly Hall of the Church of Scotland. Originally, this was the first home of the Free Church of Scotland, which was formed following a split from the Church of Scotland in 1843 (known as the Great Disruption). The two churches reconciled in 1929.

109

North West Circus Place

Photo spot: Stockbridge.
what3words ref: unions.bronze.riders

Direction: Facing west, 283°W

Camera zoom: x1

Best time of day: Afternoon, with the sun to the left.

Additional shot: Move across the street to capture a shot with the house and the staircase straight-on.

Selfie spot: Take a selfie from the bottom of the steps, but make sure no one is coming in or out of the house at the time.

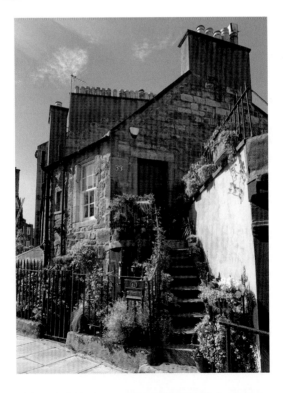

...cont'd

About this photo

Getting there: From Princes Street at the junction with Frederick Street at **prone.taps.noses**, walk north up Frederick Street, cross George Street and Queen Street, and continue along Queen Street Gardens West and Howe Street (approximately 600 metres). At **lock.learn.mull**, turn left along South East Circus Place/Circus Place/North West Circus Place and continue for approximately 250 metres until you reach the photo spot at the junction with India Place.

Photo fact: The house on the corner of North West Circus Place is typical of the gems that you can discover while walking in Edinburgh. It is a private home, but the staircase surrounded by potted plants and hanging baskets provides a delightful photo in the heart of the city; however, make sure you respect the house's residents.

Nearby food and drink: Stockbridge has a plethora of excellent options for all kinds of eating and drinking.

Nearby attractions: Nearby Circus Lane (off North West Circus Place at **gentle.cube.images**) is equally photogenic with its cobbled street and mews housing.

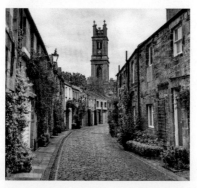

Heart of Midlothian

Photo spot: Lawnmarket, Royal Mile.
what3words ref: foam.less.parent

Direction: Facing west, 252°W

Camera zoom: x2

Best time of day: Morning, with the sun behind.

Additional shot: The location of the Heart of Midlothian provides a good spot for a shot of the Royal Mile, looking along High Street towards Holyroodhouse Palace. Turn around to capture a similar shot but facing up towards Edinburgh Castle at the top of the Royal Mile.

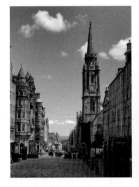

Selfie spot: Crouch next to the Heart of Midlothian to capture a selfie with it.

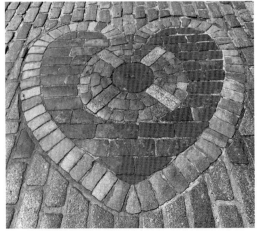

...cont'd

About this photo

Getting there: From the junction with the Mound (Bank Street) and George IV Bridge at **doing.exams.poppy**, turn left onto Lawnmarket. Cross Lawnmarket and continue for approximately 65 metres until you reach the photo spot.

Photo fact: Although it can be easy to miss it underfoot, the Heart of Midlothian cobbled mosaic marks significant aspects of both modern and historical Edinburgh. Taken from the title of a Sir Walter Scott novel, it marks the spot where the Old Tolbooth stood. This served many purposes through history from when it was built in the 14th century: it was the centre of municipal government, held the early meetings of the Parliament of Scotland, and hosted the Court of Session. However, its most well-known role was as a notorious prison, renowned for its terrible conditions and torture of prisoners. It was also the site where public executions took place on its roof so that the watching public could get a good view. The Old Tolbooth was demolished in 1817, much to the relief of most of the residents of Edinburgh. In modern times, the Heart of Midlothian is associated with the Edinburgh football team of the same name (the other top-flight team in Edinburgh is Hibernian FC). One rather unsightly consequence of this is that fans of the club consider it good luck to spit on the mosaic when they pass. The habit of spitting on the Heart of Midlothian is thought to have originally been a sign of disdain for the events that took place in the Old Tolbooth, but it gradually became considered a sign of good luck.

Nearby food and drink: As for the St. Giles' Cathedral photo on pages 88-89.

Nearby attractions: Walk along the Royal Mile to explore the shops, pubs and restaurants on Cockburn Street on the left-hand side at **races.chin.slimy**.

Advocates Close

Photo spot: Lawnmarket, Royal Mile, opposite St. Giles' Cathedral.
what3words ref: cared.tubes.pulled

Direction: Facing northwest, 335°NW

Camera zoom: x1

Best time of day: Afternoon, with the sun to the left.

Additional shot: Move backwards or forwards in Advocates Close to get the best framing of the monument.

Selfie spot: It is a bit of a tight squeeze, but it is possible to capture a selfie from the end of the close with the Scott Monument in the background behind you.

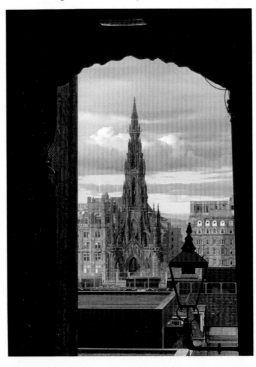

...cont'd

About this photo

Getting there: From the junction with the Mound (Bank Street) and George IV Bridge at **doing.exams.poppy**, turn left onto Lawnmarket. Continue for approximately 85 metres along the left-hand side of Lawnmarket until you reach the photo spot.

Photo fact: The Royal Mile has numerous "closes" that lead off the main thoroughfare, usually through an arched entrance. They lead to other parts of the Old Town, and also buildings hidden away from the Royal Mile itself. Before the development of the New Town, Advocates Close was one of the most prestigious addresses in

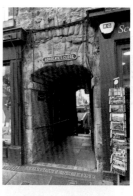

the city, and takes its name from one of Edinburgh's Lord Advocates of Scotland who had an impressive home here. If you walk through the close, the photo on the opposite page comes into view, framed by the archway of the close.

Nearby food and drink: Continue through Advocates Close to The Devil's Advocate pub at **undulation.aware.stays**. It has a comfortable, warm atmosphere, and serves food as well as offering over 300 different whiskies.

Nearby attractions: Before Advocates Close at the top of Lawnmarket is the Edinburgh High Court at **museum.forest.short**. This comprises the civil court, the Court of Session (created in 532) and the High Court of Justiciary (created in 1672), which deals with criminal cases. Together, they are known as the Supreme Courts of Scotland.

Jacob's Ladder

Photo spot: From the bottom of Calton Hill to Calton Road.
Top: **what3words ref**: **woes.exchanges.fired**
Bottom: **what3words ref**: **thank.nail.fits**

Direction: Facing northeast, 46°NE

Camera zoom: x1

Best time of day: Any time of day.

Additional shot: From the top of Jacob's Ladder, look east
to capture a photo including Waverley Station.

Selfie spot: From the bottom of Jacob's
Ladder, a selfie can be captured with the steps
ascending steeply behind you.

...cont'd

About this photo

Getting there: From the entrance to Calton Hill at **digit.slate.stage** (see Calton Hill 1 photo on pages 74-75), walk approximately 250 metres west along the right-hand side of Regent Road until you reach the photo spot, 50 metres past the roundabout.

Photo fact: Jacob's Ladder staircases appear in a number of cities around the world and are a biblical reference to a steep path that Jacob dreamed of in the book of Genesis, which linked Heaven and Earth, resulting in the steep nature of the steps. The first references to Edinburgh's Jacob's Ladder were at the end of the 18th century when it was thought to have been used as a funeral procession route to the Old Calton Burial Ground (although it would have been a steep walk for a funeral party). However, over the years, Jacob's Ladder fell into disrepair until 2019 when it was renovated and restored through a partnership with Edinburgh City Council, Edinburgh World Heritage, and New Waverley. The renovation cost £150,000 and has restored Jacob's Ladder as a convenient (if steep) shortcut between the Old and New Towns. The stairs are also lit at night time. Other Jacob's Ladder steps can be found in England (Sidmouth), Australia (Perth), New Zealand (as a sculpture, near Auckland), and Saint Helena (Jamestown) in the Atlantic Ocean.

Nearby food and drink: The nearest refreshment stops are on Waterloo Place, before you reach Regent Road (see Calton Hill 1 photo on pages 74-75 for details).

Nearby attractions: Further along Regent Road are the Old Royal High School at **snack.chart.reduce** (see pages 80-81), and the Burns Monument at **strict.souk.twin**.

St. Cecilia's Hall

Photo spot: Cowgate.
what3words ref: school.clots.timing

Direction: Facing east, 100°E

Camera zoom: x1

Best time of day: Afternoon, with the sun to the right.

Additional shot: Zoom in on the metallic panel for a detailed shot (see the next page).

Selfie spot: The metallic panel at the front of St. Cecilia's Hall makes an excellent background for an artistic selfie.

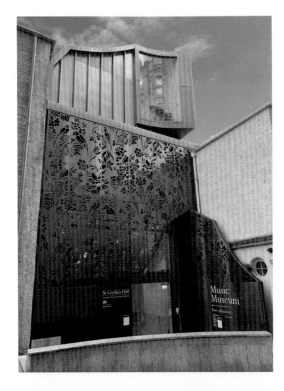

About this photo

Getting there: From the junction with the Mound (Bank Street) and George IV Bridge at **sends.hello.energetic**, walk south along George IV Bridge and turn right along Victoria Street at **proven.guess.woof**. Walk to the bottom of Victoria Street and continue left along Cowgatehead at **loudly.amber.chase**, which becomes Cowgate. Continue 500 metres along Cowgate and turn left up Niddry Street at **maybe.buns.cling**. St. Cecilia's Hall is facing you on the right-hand side.

Photo fact:
Although the front of St. Cecilia's Hall makes for an eye-catching photo, it is also the oldest purpose-built concert hall in Scotland (and the second-oldest in the UK), dating back to 1763. In addition to holding concerts, it houses a free museum consisting of the University of Edinburgh's extensive and historic collection of musical instruments. St. Cecilia's Hall has been developed and renovated on numerous occasions, with the most recent one being completed in 2017, including the striking metallic entrance.

Nearby food and drink: Bannermans pub on Cowgate, just past Niddry Street heading east at **kinks.silly.dull**, is an Edinburgh pub steeped in history, much of which is narrated on plaques on the outside of the building. It is also well known as an excellent live music venue.

Nearby attractions: The Cowgate features prominently in the history of Edinburgh, not always for the best reasons, but it is an area of the city that probably best captures the atmosphere of years gone by.

Magdalen Chapel

Photo spot: Cowgate.
what3words ref: youth.fantastic.cities

Direction: Facing southeast, 150°SE

Camera zoom: x1

Best time of day:
Morning, with the sun to
the left.

Additional shot: From the
bottom of Victoria Street
(see the next page), capture
a shot of Grassmarket with
Edinburgh Castle in the
background.

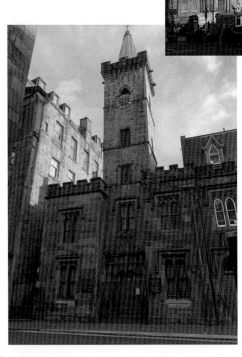

...cont'd

About this photo

Getting there: From the junction with the Mound (Bank Street) and George IV Bridge at **sends.hello.energetic**, walk south along George IV Bridge and turn right along Victoria Street at **proven.guess.woof**. Walk to the bottom of Victoria Street and continue left along Cowgatehead at **loudly.amber.chase**, which becomes Cowgate. The Magdalen Chapel is 100 metres along Cowgate heading east, on the right-hand side.

Photo fact: The Magdalen Chapel dates back to 1541, and not only served as a place of religious worship and as an almshouse for the poor (some of whom prayed for the soul of Mary, Queen of Scots), but also as the guildhall for the Incorporation of Hammermen. Edinburgh has a long history of its skilled workers forming associations in order to protect their interests, and this was a trade guild for all metal workers in the city. Following the Reformation of Scotland in the 16th century, the Magdalen Chapel was used as a meeting place for the Reformed Church of Scotland, but despite the Reformation, the chapel retains the only intact pre-Reformation stained glass panel in a Scottish place of worship. The Magdalen Chapel is a Category A listed building and is now the headquarters of the Scottish Reformation Society.

Nearby food and drink: Head west along Cowgate to Grassmarket for a wide range of pubs, cafés and restaurants.

Nearby attractions: The Candlemaker Row Viewpoint at the roundabout at the bottom of Candlemaker Row and Cowgatehead at **donor.cycles.transit** is an excellent spot to capture photos along Cowgate, and also Grassmarket with Edinburgh Castle in the background – see the previous page.

Princes Street Gardens Cottage

Photo spot: In the corner of West Princes Street Gardens.
what3words ref: deflection.deeper.mercy

Direction: Facing northeast, 41°NE

Camera zoom: x1

Best time of day: Afternoon, with the sun behind.

Additional shot: The castle looms behind you from here, and it is a good spot for some dramatic shots.

Selfie spot: With the cottage and its garden behind you, it is an excellent location to get a picture-postcard selfie.

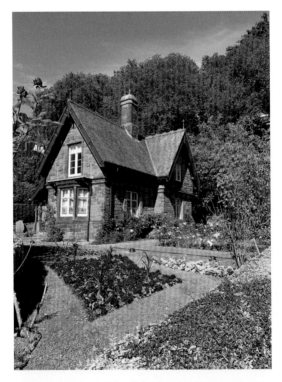

...cont'd

About this photo

Getting there: From Princes Street at the junction of Hanover Street at **dated.pass.ripe**, cross to the other side of Princes Street and turn right past the Royal Scottish Academy. Cross over the Mound and enter Princes Street Gardens at **excuse.parks.trout**. Walk down the steps, past the Floral Clock, and turn left onto the path at **myself.dress.slide**. Walk around the path, with the Cottage on your right-hand side, until you reach the photo spot.

Photo fact: The cottage in West Princes Street Gardens (also known as the Gardener's Lodge) dates back to 1886, when it was used by the head gardener of the gardens. It was built when the West Princes Street Gardens were being redeveloped as a public park, similar to how they look today. The cottage is no longer open to the public, but there is occasionally public access during Edinburgh's Doors Open Days – an annual event that provides access to a range of notable public buildings in the city. The inside of the cottage has been renovated with many of its original features, with a particularly impressive dining room.

Nearby food and drink: Princes Street Gardens is an ideal location for a picnic (weather permitting), and there is sometimes an ice-cream van doing the rounds in the gardens.

Nearby attractions: On the way to the cottage, you pass the Floral Clock on the steps down into Princes Street Gardens (see pages 60-61 for details about Edinburgh's Floral Clock).

Castle from St. Cuthbert's

Photo spot: From the grounds of St. Cuthbert's Church, in Edinburgh's West End.
what3words ref: **wizard.yard.marked**

Direction: Facing southeast, 75°SE

Camera zoom: x1.5

Best time of day: Late afternoon, with the sun to the right.

Additional shot: St. Cuthbert's Church offers some good photographic opportunities, particularly in the evening as the sun is setting.

 Selfie spot: Try taking a selfie at dusk, when the graveyard is atmospheric or even ghostly!

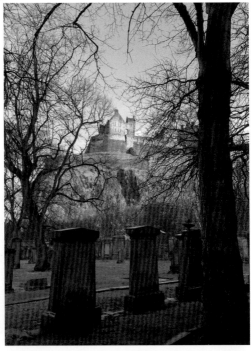

...cont'd

About this photo

Getting there: From Princes Street at the junction of Hanover Street on the Princes Street Gardens side at **logic.buyers.lucky**, walk west along Princes Street for 360 metres and turn left into Princes Street Gardens at **pizza.guard. recent**. Walk west along the path to the entrance of St. Cuthbert's Church at **asleep.clay.palm**. Walk west along the path for 60 metres at **chef.occupy.usage**. Follow the path around to the right to reach the photo spot.

Photo fact: The Parish Church of St. Cuthbert lies in the west end of Princes Street, at the bottom of Lothian Road. The site where the current St. Cuthbert's sits is the location for what is thought to be the oldest Christian site in the city. In its heyday, the parish covered by St. Cuthbert's was extensive but as the city developed more parishes grew up, and so the reach of St. Cuthbert's was reduced. It became a Protestant church during the Scottish Reformation in the 16th century, and it remains so today. The current St. Cuthbert's Church was completed and dedicated in 1894.

Nearby food and drink: If you walk up Lothian Road, there is good selection of restaurants and pubs.

Nearby attractions: On the way to the photo spot in Princes Street Gardens at **drum.bubble.noted** is the Wojtek the Soldier Bear Memorial. This commemorates Wojtek the bear and the Polish regiment that adopted him. After World War Two, the regiment moved to Scotland where many of them remained, including Wojtek who moved to Edinburgh Zoo where he died in 1963, aged 22.

Miscellaneous Details

While it can be great to capture photos of iconic and interesting sites around a city, there are always hidden photographic gems that you will stumble across as you go around different locations. The important thing is to keep a lookout for miscellaneous photo opportunities, as well as the traditional ones. Some areas to keep an eye out for are:

- **Details of buildings**. These help to convey the character of buildings, rather than just their overall appearance. This can cover a multitude of elements: windows, door handles, artwork, tiles, and stone structures.

- **Contrasting colours**. Colour is one of the cornerstones of photography, and strong contrasts can create striking images. Conversely, black and white photos can create artistic and evocative scenes.

- **The quirky and quaint**. Cities are filled with weird and wonderful photo opportunities: it's just a question of noticing them. This can be done by spending a little bit of time looking around your surroundings, rather than just rushing from one attraction to another.

6 Old Town Walk

Featuring hundreds of years of history, Edinburgh's Old Town is somewhere where you could spend days wandering streets linked with numerous narrow closes and wynds.

This walk distils the essence of the Old Town so that you can discover some of its history and secrets. The walk is centred on the Royal Mile, as it stretches from Edinburgh Castle to Holyroodhouse Palace. Along the way, the walk details some of the history of the Royal Mile and the Old Town, showing how they developed the unique characters that they have today. The walk also reveals some of the famous people who inhabited the Old Town – from the religious reformer John Knox to one of the key figures in the Scottish Enlightenment, philosopher David Hume.

Once you have completed the Old Town walk, the secrets of Edinburgh's past may be brought into much clearer focus.

Old Town Walk Introduction

This walk takes in some of the top sights in the city, including Edinburgh Castle, the Royal Mile, St. Giles' Cathedral, and Holyroodhouse Palace.

Distance: 3.5 km. **Approx. number of steps**: 5,000.

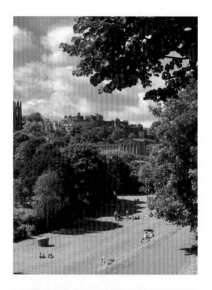

Historical note – Nor' Loch

Before the creation of the New Town, the foot of Edinburgh Castle was occupied by an expanse of water known as the Nor' Loch. This was no quaint water feature but rather a repository for people's rubbish and waste of all descriptions, and the water was never clean enough to be used for drinking. When the New Town was proposed it was agreed that the Nor' Loch would not be a suitable accompaniment for the new residents, so it was drained over a period of time, starting in 1759. This began at the east end of Princes Street to make way for North Bridge, which was built to be the main link between the Old and New Towns.

Starting Point

The Old Town walk starts at the foot of the Scott Monument, at **what3words** ref: **lows.hits.arrive**. Although this is on the edges of the New Town, it also borders Princes Street Gardens, which as the Nor' Loch formed an important part of the Old Town.

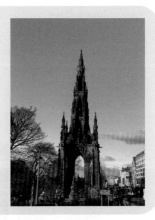

Walk Details

1 Walk west along Princes St. until you reach the bottom of the Mound at **harp.divide.tell**. Cross at the crossing, to see the statue of Allan Ramsay at **rate.glory.plot**

Historical note – Allan Ramsay

Edinburgh has always had a long poetic tradition, with poets also known as "makars". One of the most famous of these is Allan Ramsay (1686-1758), who lived in what is now Ramsay Garden. Ramsay frequently wrote in the Scots vernacular, which had a considerable influence on his contemporaries. He also founded a lending library and a theatre.

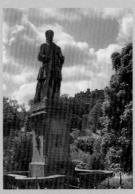

2 Walk up the right-hand side of the Mound and turn right at **cheat.orders.pools** onto Mound Place

Photo stop – Ramsay Garden

Halfway up the Mound, stop at **strut.leader.super** to take a photo of Ramsay Garden, to the right.

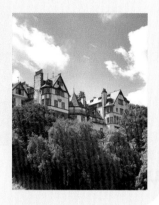

3 Mound Place continues onto Ramsay Lane, towards the castle, passing Ramsay Garden on the right at **steps.likely.scan**

Photo stop – Princes Street

When on Mound Place at **begin.vocal.office**, turn northeast to take a photo of the Edinburgh skyline, featuring Princes Street, the Scott Monument and the "Ribbon Hotel".

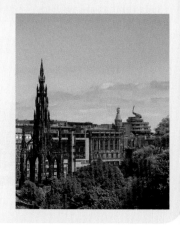

4 At the top of Ramsay Lane, turn right at **studio.fuel.corn** onto Castlehill

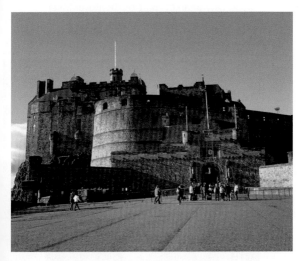

5 Walk up Castlehill to Edinburgh Castle Esplanade at **over.froze.ahead**

Refreshment stop – The Witchery

The Witchery at **noise.trees.count** is an enchanting restaurant near the castle that celebrates Edinburgh's historical association with witches.

6 After viewing the castle, turn around and head along Castlehill. Keep heading straight ahead to go along Lawnmarket (part of the Royal Mile)

Historical note – Royal Mile

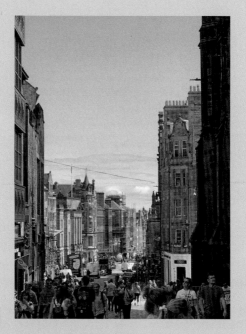

Edinburgh's Royal Mile does exactly what the name suggests: it connects the city's two royal buildings – Edinburgh Castle and Holyroodhouse Palace – and is nearly exactly a mile (approximately 1.6 km). Although it is one continuous thoroughfare, it comprises four separate elements (from the castle, heading down to Holyroodhouse Palace): Castlehill, Lawnmarket, High Street, and Canongate. Edinburgh's Old Town grew up around the Royal Mile, as the tenements, closes and wynds spilled out on either side. Few of the original buildings remain today, but much of the design is still the same, giving an evocative idea of what life was like here hundreds of years ago.

7 Cross Lawnmarket at Bank Street at **likely.marker.taking**. Looking along Lawnmarket toward St. Giles' Cathedral is a statue of David Hume, the 18th-century philosopher, historian and writer, at **type.stamp.polite**. Hume, who lived from 1711 to 1776,

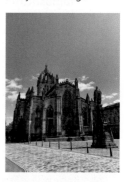

was one of Scotland's greatest philosophers, and contributed hugely to the Scottish Enlightenment with his most famous work, *A Treatise of Human Nature*. However, he has also attracted controversy in recent years, due to some of his approaches to issues of race and his involvement in the slave trade. In September 2020, his name was removed from one of Edinburgh University's buildings

8 Walk past St. Giles' Cathedral at **method.shades.closed** and continue along High Street for approximately 300 metres (see pages 88-89 for details about St. Giles' Cathedral)

Refreshment stop – High Street

Gordon's Trattoria at **finishing.winter.moment** is something of an institution on High Street. It has been there for over 40 years, serving fine Italian food in the heart of Edinburgh – testament to the strong links that the city has with the Italian community.

9 At the junction of High Street and North/South Bridge stands the Tron Kirk at **wisely.lions.medium**, with Hunter Square behind it. This is where locals used to gather to celebrate Hogmanay and welcome in the New Year, before the more organised celebrations along Princes Street

10 Cross the Bridges at the junction and continue along the left-hand side of High Street for 100 metres. Stop at **fantastic.rungs. lanes** to view John Knox House, the former home of the Scottish religious reformer

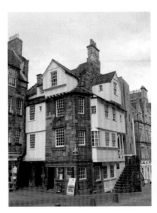

Historical note – John Knox

John Knox was a Scottish religious minister who was leader of the Protestant Reformation in Scotland in the 16th century. Knox was renowned for his firebrand sermons at St. Giles' Cathedral, and clashed regularly with Mary, Queen of Scots due to her support for the Catholic faith. He is credited with creating the Scottish Presbyterian movement. He wrote numerous religious books, including the five-volume *The History of the Reformation in Scotland*.

11 From John Knox House, head along High Street until it becomes Canongate at **fields.title.perky**

12 Walk approximately 300 metres along Canongate until you reach Canongate Kirkyard at **letter.flute.such**

13 At the entrance of the Kirkyard is a statue of Robert Fergusson, a poet who is thought to have been an inspiration for Robert Burns. Fergusson died at the young age of 24 and is buried in the Kirkyard

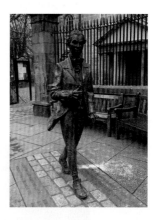

14 Take some time to explore Canongate Kirkyard, which contains the graves and mausoleums of some of the great and the good of Edinburgh society over the generations, including the world-renowned economist

Adam Smith; George Drummond, who was Lord Provost of Edinburgh on six occasions and also had the original vision for the creation of the New Town; and Dugald Stewart, the philosopher, mathematician and teacher, whose monument stands on Calton Hill

15 From Canongate Kirkyard, continue along Canongate for approximately 300 metres to reach the end of the Royal Mile, where the old and the new are seen side by side in the form of the Scottish Parliament building and Holyroodhouse Palace at **feared.upgrading.forest**

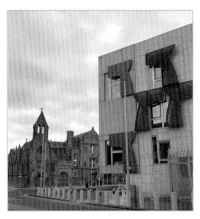

Historical note – Holyroodhouse Palace

The history of Holyroodhouse Palace dates back to 1128, when King David I of Scotland was inspired to build an abbey after seeing a vision of a stag. Since then, it has been the home of the Scottish and British monarchy, and Queen Elizabeth II stays here for a week in the summer every year, hosting her annual Garden Party. Holyroodhouse Palace has seen its fair share of political intrigue and dark deeds over the years, including: the murder of Mary, Queen of Scots' secretary, David Rizzio, by a group led by her husband, Lord Darnley; Bonnie Prince Charlie briefly using the palace to further his Jacobite cause; and Oliver Cromwell using it as barracks for his troops during the English Civil War.

16 At the roundabout at the bottom of Canongate, turn left at **forms.game.impose** and almost immediately left again onto Calton Road at **cloth.tried.career**

17 Walk along Calton Road for 100 metres until you reach New Calton Burial Ground on the right-hand side at **rarely.sling.cracks**

18 New Calton Burial Ground has the graves of some notable Edinburgh figures, including Robert Louis Stevenson's father, Thomas; William Dick, a well-known vet who founded Edinburgh's Dick Vet College of veterinarian medicine; and Richard Jordan, who was Scotland's undefeated world draughts (checkers) champion. The hillside location of New Calton Burial Ground also provides excellent options for taking photos of Arthur's Seat and the Scottish Parliament

19 Exiting New Calton Burial Ground, turn right and continue for approximately 300 metres until you reach Old Tolbooth Wynd at **bike.less.client**

20 Walk up Old Tolbooth Wynd and rejoin Canongate, turning right at **blur.drips.smoke**

21 Walk back up the Royal Mile for approximately 650 metres to finish the walk at the Mercat Cross outside St. Giles' Cathedral at **spit.music.hung**

Shopping stop – Royal Mile

As you walk up the Royal Mile, take some time to explore the variety of shops there, ranging from kiltmakers, whisky shops, cashmere shops, and even two permanent Christmas shops!

More Old Town Locations

Three more Old Town locations to track down are:

- **The Flodden Wall**. After the defeat of the Scots at the Battle of Flodden in 1513, fear of an English invasion was running high. This resulted in the creation of the Flodden Wall, encompassing the city, with various gates (called Ports) that could be used to guard the city. Remnants remain around the Old Town, including at **humans.spine.tell**.

- **George Heriot's School**, Lauriston Place at **lied.rental.shine**. One of Edinburgh's numerous private schools, thought by many to be the inspiration for Hogwarts School of Witchcraft and Wizardry in the *Harry Potter* books.

- **Beehive Inn**. Located in Grassmarket at **stones.caller.luxury**, the Beehive is one of Edinburgh's oldest pubs, with a restaurant on the first floor that includes the door from the condemned cell of Old Calton Jail. In the 1990s, a notorious but

reformed gang leader was dining in the restaurant, and was asked to pose for a photo in front of the doo from the condemned cell. He declined!

140

7 New Town Walk

This walk reveals a very different side of Edinburgh from the close-packed tenement buildings of the Old Town. By comparison, the New Town is a picture of ordered refinement, with its rows of elegant Georgian houses, wide streets, and large gardens reserved for the private use of residents.

The New Town was a deliberate attempt by the great and the good to escape the overcrowding and unsanitary conditions of the Old Town. For centuries rich and poor had lived side by side, and frequently on different floors of the same tenement building, but by the beginning of the 18th century this state of affairs was becoming unsustainable. Things came to a head in 1752 when a tenement collapsed. Although this was not an uncommon occurrence, it led to a report into the living conditions in the Old Town. The result was a competition to design the New Town. This walk reveals the results of that competition and the seismic impact it had on the city and its appearance.

New Town Walk Introduction

In contrast to the Old Town walk, this walk reveals a very different side of Edinburgh, focusing on the wide streets and Georgian architecture of the New Town.

Distance: 4.2 km. **Approx. number of steps**: 6,300.

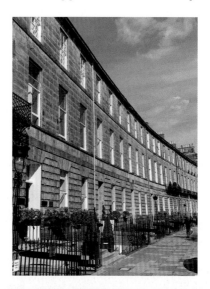

Historical note – New Town

The First New Town, as it was known, was a deliberate attempt to create an ordered and more refined extension of the city, as opposed to the ramshackle nature of the Old Town. Designed by a young architect named James Craig, it embraces a symmetrical structure, with many of the streets bearing patriotic or royal names. Work started on the New Town in 1767. Craig originally wanted it to be modelled on the Union Flag, but pragmatic reasons prevented this from fully coming to fruition. The conformity of many of the Georgian buildings in the New Town is down to legal requirements regarding their construction in terms of materials used and design.

Starting Point

The New Town walk starts at the east end of Princes Street in front of General Register House, at **what3words** ref: **drive.admits.kite**. This houses the public records of births, deaths and marriages in Scotland. The statue at the front is of the Duke of Wellington.

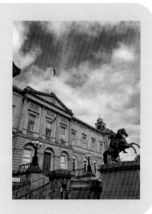

Walk Details

1 To the left of General Register House, turn right up West Register Street at **liver.deed.castle**, passing two traditional Edinburgh pubs, the Guildford Arms and the Cafe Royal

Walk detour – James Craig

As an alternative start to the walk, go to the right of General Register House and turn left up James Craig Walk. Continue along James Craig Walk for 150 metres, as it turns into James Square opposite the "Ribbon Hotel", to view a plaque at

gravel.reward.loaf commemorating James Craig, the original architect of the First New Town. Retrace your steps to Step 1 on page 143.

2 Exit West Register Street at **cure.shadow.juices** and turn right onto South St. Andrew Street

3 Continue 100 metres onto St. Andrew Square and turn left into St. Andrew Square Garden at **label.noises. liked**

Historical note – St. Andrew

Scotland's patron saint, St. Andrew, was an apostle of Jesus and brother to St. Peter. He gives his name to the town of St. Andrews on the east coast of Scotland, in Fife. St. Andrew's feast day is 30 November, celebrated in Scotland with traditional haggis, neeps and tatties (see page 39), and a nip or two of whisky.

4 Walk through St. Andrew Square Garden, exiting at **spicy.poems.cities**, crossing St. Andrew Square onto George Street

Historical note – Henry Dundas, Lord Melville

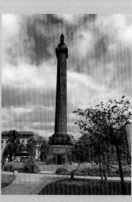

The figure at the top of the column in St. Andrew Square Garden is Henry Dundas (1742-1811), a significant political figure in the 18th century, although he has become increasingly controversial through the lens of history. As with many leading figures in Edinburgh society, Dundas originally made a name for himself in law, becoming the Solicitor General for Scotland in 1766. He also enjoyed a significant political career, holding several senior positions in the government of William Pitt, and virtually controlling the political scene in Scotland for several decades during the latter part of the 18th century. However, Dundas' legacy has been tainted by accusations that he prolonged the slave trade, and there is a plaque near to the monument that explains this historical context.

5 Walk along George Street, passing the statue of the great physicist James Clerk Maxwell at **rate.person.hills**. James Clerk Maxwell was born in Edinburgh and is one of the most famous names in science, primarily due to his work on electromagnetic radiation

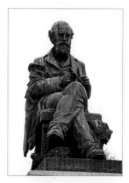

145

6 Continue along George Street, past St. Andrew's and St. George's West Church on the right-hand side at **lawn. coats.cove**, with its notable classic facade

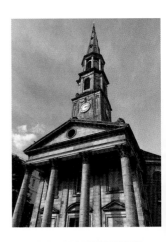

Historical note – George Street

George Street lies at the heart of the First New Town, both geographically and in terms of the architectural vision of what was a brave new world. Named after the then-monarch, George III, who approved its final plans, it stretches for a similar length to Princes Street, from St. Andrew Square in the east to Charlotte Square in the west.

7 When George Street reaches Hanover Street at **ended.badge.bubble**, turn right along Hanover Street

8 Walk along Hanover Street for 275 metres, crossing Queen Street, continuing along Queen Street Gardens East

9 Turn right onto Abercromby Place at **mime.cove.rear**

10 Abercromby Place is a classic New Town street, with its curving bank of Georgian flats, its wide street, and a large garden along the north side of the street. This garden is typical of the New Town and is for the private use of residents, who have keys for access through gates that are located along the perimeter of the railing around the garden. The original purpose of this type of garden was to give the well-heeled residents of the New Town some green space to escape from the stresses of city life

11 Walk east along Abercromby Place for 300 metres, past Nelson Street on the left, until you reach Dublin Street at **glory.down.wooden**. Turn left along Dublin Street

Refreshment stop – New Town

The culinary treats of the New Town can be fairly well hidden, and one of them is on Dublin Street:

Stac Polly at **create.bill.laptop** is two restaurants together – one a brasserie-style restaurant, and the other a more formal setting, both serving modern Scottish cuisine.

12 Head south along Dublin Street and take the first left, into Dublin Meuse at **votes.crab.stage**

13 Walk through Dublin Meuse, past the attractive houses and cottages. Turn right at the end of Dublin Meuse at **model.shades.equal** onto Northumberland Place, which becomes Northumberland Street

Photo stop – Gardens and Doors

The New Town is full of decorative doors and basement gardens, so it is worth paying attention to these as you are passing and taking the chance to take some photos of these traditional New Town features and highlights.

14 Continue along Northumberland Street for 400 metres, passing the house at number 25 – where Sir Walter Scott's son-in-law and biographer John Gibson Lockhart lived from 1821 to 1825 – and cross Dundas Street

15 At the end of Northumberland Street at **alive.clever.cheat**, turn right, heading south along Howe Street

16 Take the next left at **league.slides.overnight**, along South East Circus Place

17 Continue along South East Circus Place as it becomes Circus Place

Refreshment stop – Stockbridge

South East Circus Place is the start of Stockbridge, and is awash with excellent cafés. Two to try are:

The Pantry at **flown.slices.lamps**. Blueberry pancakes are a particular specialty.

Patisserie Florentin at **judges.silks.tooth**. A relaxed atmosphere and an enticing range of pastries and cakes.

18 As Circus Place becomes North West Circus Place, turn right along Circus Lane at **gentle.cube.images** to get a photo of this picturesque location (see page 111 for details)

19 From Circus Lane, retrace your steps to North West Circus Place. Turn right, cross the road, and turn left onto India Street at **smile.fallen.cross**

20 Continue along India Street for 50 metres and turn left onto Gloucester Street at **agenda.sushi.chefs**

Historical note – Moray Estate

Containing some of the most exclusive addresses in the city, the Moray Estate is an area of 19th-century urban development, centred on the circular Moray Place, that helped to expand the New Town to the west. In 1782, the 9th Earl of Moray acquired over five hectares of land in Edinburgh's West End. 30 years later, the 10th Earl of Moray started to develop the land, building over 150 magnificent townhouses with equally impressive private gardens. The houses were in high demand, and this remains the case today.

21 Walk north along Gloucester Street/Gloucester Lane/Wemyss Place for approximately 400 metres until you reach Queen Street, at **sobs.theme.flips**

22 Turn right onto Queen Street/Albyn Place, turn next left onto North Charlotte Street, and continue 80 metres north to Charlotte Square

Walk detour – The Oxford Bar

From North Charlotte Street, turn left onto Young Street at **kind.visual.cheat** and walk 140 metres until you reach The Oxford Bar at **entry.dices.admire**, which was a favourite haunt of the fictional detective John Rebus, and also – coincidentally – his creator, Ian Rankin.

23 Turn first right onto the south side of Charlotte Square at **panels.string.formal**

24 Walk 75 metres until you reach Bute House, the official residence of Scotland's First Minister, at **book.casual.slurs**

Historical note – Charlotte Square

Designed to mirror St. Andrew Square at the east end of George Street, Charlotte Square was one of the last elements of the First New Town to be completed, in 1820. It was originally intended to be named St. George Square but this was changed to Charlotte Square, using the names of King George III's wife and daughter. Much of Charlotte Square was designed by one of the most famous architects of the day, Robert Adam (1728-92), who unfortunately died before much of the construction could be started. The Charlotte Square gardens are not generally open to the public, although the Edinburgh International Book Festival takes place there in August each year.

25 Cross the road to the garden in the middle of the square and walk around the east side of the garden. Cross the road at the south side of Charlotte Square at **pushed.normal.dined**, and walk 75 metres to see the house where the inventor of the telephone, Alexander Graham Bell, was born at **adopt.topic.frame**

26 Cross the road over Charlotte Square, walk north up to George Street, and turn right at **fame.pack.posed**

27 Walk along George Street for 180 metres and turn left along North Castle Street at **risk.master.older**

28 Cross to the east side of North Castle Street to view the house where Sir Walter Scott lived from 1802 to 1826 at **shakes.toys.ranked**

29 Walk back to George Street and cross over to Castle Street at **salads.cattle.bricks**

30 Head along Castle Street and turn left onto Rose Street at **float.invest.dame**

31 Walk along Rose Street for 400 metres (crossing Frederick Street), sampling the shops, restaurants and bars that line either side, until you reach Hanover Street at **motor.loaded.port**

32 Turn right along Hanover Street to return to the walk's starting point

More New Town Locations

More locations and sights around the New Town that are worth a visit include:

- Scottish National Portrait Gallery, 1 Queen Street, at **indoor.view.busy**.

- Robert Louis Stevenson House, 17 Heriot Row, at **brick.alive.window**, where Stevenson lived from 1856 when he was aged six, until he left Scotland in 1880.

- James Clerk Maxwell House, 14 India Street, at **trim.combining.await**. This was the birthplace of the great scientist in 1831, and now houses the James Clerk Maxwell Foundation.

- J. M. Barrie House, 3 Great King Street, at **land.divide.motion**. It was here that the *Peter Pan* author lodged on the top floor, from 1879 to 1892.

- Dr. Joseph Bell, 22 St. Andrew Square, at **ballots.relate.port**. The birthplace of the man who was Sir Arthur Conan Doyle's inspiration for *Sherlock Holmes*, although the house is now a hotel.

- Royal College of Physicians of Edinburgh, 9 Queen Street, at **suffer.figure.purple**. Dating from 1617, the college has contributed significantly to medical advancements made in the city, and its members have included many famous scientists over the centuries.

- 15 London Street, at **emerge.vouch.detail**. Somewhat bizarrely, this was the location for the composition of the Icelandic national anthem in 1874. It was composed and written by composer Sveinbjörn Sveinbjörnsson and poet Matthías Jochumsson. A plaque on the wall of the house commemorates the event.

(8) Literary Walk

Edinburgh has as rich a literary heritage as anywhere in the world. From Sir Walter Scott and Robert Burns to Robert Louis Stevenson and Sir Arthur Conan Doyle, the most famous writers of the day have visited, lived in or studied in Edinburgh. Modern luminaries including J. K. Rowling and Ian Rankin (the author of the **Rebus** series of detective novels) also have strong links to the capital, and its streets are full of points of interest for the literary-minded.

This walk brings some of Edinburgh's most famous writers off the page so that you get a real feeling of when they were living and working in Edinburgh. From locations where the likes of Walter Scott and Arthur Conan Doyle lived in the city to the pub that Robert Louis Stevenson frequented during his student days (and the cafés where J. K. Rowling wrote some of the **Harry Potter** series), the walk shows that it is impossible to go too far in the city without coming across an important literary reference point or location.

Literary Walk Introduction

This walk follows in the footsteps of some of Edinburgh's literary greats, showing where they lived and worked.

Distance: 3.25 km. **Approx. number of steps**: 4,800.

Historical note – Edinburgh Review

In addition to the long list of world-famous writers who have graced Edinburgh, it is also renowned in the literary world for producing one of the finest literary magazines of its day: *The Edinburgh Review*. Founded in 1802, the *Review* endured for over 100 years, until 1929. During this time, it contained contributions from the best writers of the day and book reviews that could often be scathing, as well as philosophical and political opinions. The *Review* could generate strong feelings, and one critical voice over the years was Lord Byron.

Starting Point

The Literary walk starts at Writer's Museum (opposite), in Lady Stairs Close, off the top of the Royal Mile (Lawnmarket) at **what3words** ref: **blame.fully.planet**. The museum features the works of Burns, Scott and Stevenson, although Ian Rankin (author of the *Rebus* novels) also gets an honourable mention.

Walk Details

1 If you walk towards the castle through Lady Stairs Close, you pass James' Court at **topic.scenes.fails**, where the famous biographer James Boswell lived. It was here that he entertained the subject of his most famous work, Samuel Johnson

2 Return to the Writer's Museum and exit Lady Stairs Close onto Lawnmarket

Author note – James Boswell

James Boswell is another of the literary lawyers who called Edinburgh home. Born in 1740, Boswell believed in living life to the full, and travelled extensively for the time. He met Samuel Johnson in London in 1763 and they became lifelong friends. Boswell went on to write Johnson's biography, considered by many to be the greatest biography ever written.

3 Above the entrance to Lady Stairs Close at **repay. animal.clocks** is a plaque that commemorates Robert Burns' visit to Edinburgh in 1786, when he lived in a building in the close

Author note – Robert Burns

Although Robert Burns was born in Alloway in Ayrshire and lived most of his life in the south of Scotland, it does not prevent Edinburgh from promoting its links with Scotland's most famous writer and poet.

Born in 1759 in a farming community, Burns quickly realised that if he wanted to develop a literary career then he needed to make himself known in the country's capital. He travelled to Edinburgh in November 1786 with the intention of promoting and publishing more of his poetry. With letters of introduction to some well-connected people, he soon became a big hit on the Edinburgh literary and social scene. He met the publisher William Creech who went on to publish the second edition of Burns' poetry, the Edinburgh edition, which included the now-world-famous *Address to a Haggis*.

The love affair between Burns and Edinburgh was fairly short-lived on both sides, and he left the city in May 1787. However, by this time his literary star was firmly in the ascendancy, and he was well on his way to becoming the world-famous figure that we know today.

4 Walk along Lawnmarket to the junction with George IV Bridge at Deacon Brodies Tavern (see below and page 174)

Refreshment stop – Lawnmarket

Deacon Brodies Tavern at **dreams.older.taking**. Deacon Brodie was a notorious Edinburgh criminal whose respectable lifestyle belied his nefarious activities, and is thought to be Robert Louis Stevenson's inspiration for *The Strange Case of Dr. Jekyll and Mr. Hyde*. Deacon Brodies Tavern is a much more agreeable option than the activities of the man himself (see page 174), including an excellent restaurant on the first floor.

5 From the junction of Lawnmarket and George IV Bridge, turn onto George IV Bridge and walk along the right-hand side at **agent.butter.larger**

Photo stop – St. Giles' and Adam Smith

St. Giles' Cathedral dominates the Lawnmarket area of the Royal Mile, and at the east end of the cathedral is a statue of Adam Smith – the world-famous economist and author of *The Wealth of Nations*, published in 1776 – at **asserts.funded.star**. Smith was a leading figure in the Scottish Enlightenment period, and his economic

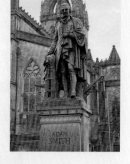

theories included the Law of Supply and Demand. He also developed the concept of gross domestic product (GDP).

6 Continue along George IV Bridge until you reach The Elephant House café at **king.clip.tester**. The Elephant House lays claim to being "the birthplace of *Harry Potter*" as it was one of the locations where J. K. Rowling first spent time writing about the boy wizard. (In 2021 the Elephant House suffered a serious fire, and at the time of printing it remains closed)

7 Just past The Elephant House café, pass the statue of Greyfriars Bobby at **vivid.keeps.vibe** and enter Greyfriars Kirkyard at **layers.ends.plates**

8 Greyfriars Kirkyard is a burial ground that contains many of the people who shaped Edinburgh society through the ages, and also a number of literary connections including the headstones of Greyfriars Bobby himself, immortalised by Eleanor Atkinson's book of the same name, and Bobby's master John Gray (also known as Old Jock), both at the entrance of the Kirkyard

9
Greyfriars Kirkyard also contains a now-famous link to *Harry Potter*: the grave of Tom Riddell – the early incarnation of Harry's nemesis, Voldemort. The grave is located at **head.claims.data**

10 Exit Greyfriars Kirkyard and turn right onto Greyfriars Place, leading onto Forrest Road, passing the Sandy Bell's pub at **clocks.likely. jabs**, which is famous for its folk music and poetry traditions

11 Continue along Forrest Road until it reaches Lauriston Place at **mime.squad.coins**, and cross over the road at the crossing

Walk detour – Arden Street and Rebus

Inspector John Rebus is the creation of local writer Ian Rankin and, over the course of over 20 novels, he has investigated crimes in all corners of the city, apprehending the great and the good of Edinburgh society and gangland killers alike. Fictionally, the curmudgeonly but always relatable Rebus lived in Arden Street in the Marchmont area, where Rankin also lived in his student years. It can be reached from Forrest Road by walking along Middle Meadow Walk to cross the Meadows. Branch off along Jawbone Walk at **cloth.minus.pint** and cross Melville Drive at **parade.arts.aware** onto Marchmont Road. Turn right onto Warrender Park Road at **loft.grow.ships** and turn next left into Arden Street at **digs.insect.roof**. Rebus's home was 17 Arden Street at **agents.random.caked**, where for many years he lived on the top floor, later having to move to the ground floor due to a heart condition.

12 Join Middle Meadow Walk at **hung.trying.crass** and continue for approximately 150 metres. Turn left at **damage.enjoyable.home** – this leads into George Square

13 Turn right into George Square at **ample.saying.blame** and walk along the west side of the square

14 At **soup.finest.hint** is the house where Sir Arthur Conan Doyle lived for a period in Edinburgh

Author note – Sir Arthur Conan Doyle

Arthur Conan Doyle may have found it elementary when he created Sherlock Holmes, but in the process he changed the face of detective fiction forever.

Conan Doyle was born in Edinburgh in 1859 and studied medicine at the University of Edinburgh. It was here that he attended lectures by Dr. Joseph Bell, who introduced him to the idea of solving problems through deduction. The first *Sherlock Holmes* novel, *A Study in Scarlet*, was published in 1886, but only after the name of the lead character was changed from Sherringford Holmes. Despite the *Sherlock Holmes* novels being a huge commercial success, Conan Doyle's first love was historical fiction, which was always overshadowed by the man in the deer-stalker, smoking his pipe. In later life, Conan Doyle turned much of his attention to the psychic world and, it is rumoured, the occult. He died in 1930.

 15 At **dime. glass.exit** is the house where Sir Walter Scott lived for a period

Author note – Sir Walter Scott

For someone who is not widely read today, it is hard to imagine the status Sir Walter Scott enjoyed in his heyday, fêted as the superstar writer of his generation. He is now generally considered to have created the genre of historical fiction, through his titles including *Waverley*, *The Heart of Midlothian*, and *Rob Roy*.

Born in 1771, Scott was a sickly child, and the weeks spent in bed helped to fuel his imagination. Following in well-worn Edinburgh footsteps, he studied law at the University of Edinburgh and qualified as an advocate in 1792. Although he remained in the legal profession, writing was his true passion, and he worked on this as he practised law. However, writing novels was not considered to be a legitimate profession (in relation to the likes of law and medicine, at least) and so when Scott published his first novel, *Waverley*, in 1814, he did so anonymously. But his work was such a success that he had to come clean and admit his secret identity. Considerable wealth followed, with which Scott built the extravagant Abbotsford residence in the Scottish Borders. In 1826, financial disaster struck when Scott was declared insolvent as the result of an ill-fated investment in a printing company. He spent his remaining days at Abbotsford, writing prolifically to pay off his debtors. Sir Walter Scott died at Abbotsford in 1832.

Scott's work has inspired more musical interpretations than any author after Shakespeare: *Ave Maria* and *Hail to the Chief* were both based on sections of his epic poem, *The Lady of the Lake*.

16 Retrace your steps to the top of Middle Meadow Walk and turn right along Teviot Place for approximately 150 metres

17 Cross the road at the crossing at **hiding.faces.jobs** and continue along Lothian Street, passing a plaque for Charles Darwin at **horns.dusty.stiff**. Darwin studied medicine at the University of Edinburgh, before his exploration to the Galapagos Islands and his seminal work on evolution, *On the Origin of Species*

18 Continue along Lothian Street until it joins South College Street at **join.hops.give**. Continue to the end of South College Street and cross the road (South Bridge) onto Drummond Street at **glee.locker.slick**

19 At the junction of Drummond Street and South Bridge is Nicolsons Cafe at **modest.lived.tinsel** – reportedly one of the locations where J. K. Rowling wrote the first *Harry Potter* novel

20 Walk along Drummond Street to the Hispaniola Bar at **cigar. commented. chain**. Formerly known as Rutherford's Bar, this was one of the favourite drinking spots of Robert Louis Stevenson

during his student days when he was studying law at the University of Edinburgh's School of Law at Old College (see the next page)

21 Return to South Bridge along Drummond Street and turn right onto South Bridge at **battle.truly.kings**

Walk detour – Surgeons' Hall Museums

On the right-hand side when walking along South Bridge is Surgeons' Hall Museums at **birds.useful.table**. The museums are located within the Royal College of Surgeons of Edinburgh building, and include

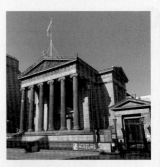

the WHOL Pathology Museum, the History of Surgery Museum, and the Dental Collection. The museums contain more preserved body parts than you are ever likely to see, and the History of Surgery Museum also has a book reputedly made from the skin of the murderer William Burke.

22 On the left-hand side of South Bridge is Old College, part of the University of Edinburgh, at **bland.dots. remark**, and where both Robert Louis Stevenson and Walter Scott studied during their time at the University of Edinburgh

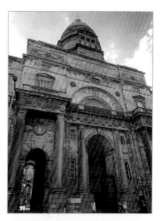

Author note – Robert Louis Stevenson

Of all of Edinburgh's great literary figures, Robert Louis Stevenson is perhaps the most intriguing. He was born in 1850 and was brought up in the family home in Heriot Row, one of the most exclusive addresses in Edinburgh. He suffered poor health as a child, which gave his extremely active imagination plenty of time to run wild. Stevenson went on to study law, and he cut a rakish figure, roaming the seedier haunts of Edinburgh in his flamboyant velvet jacket.

A career in law was never really likely for Stevenson, and he quickly started to indulge his twin passions of writing and travel. In 1883 he captured the literary world's attention with the publication of *Treasure Island* – a classic adventure story. He followed this with *The Strange Case of Dr. Jekyll and Mr. Hyde* and *Kidnapped*, cementing his reputation as the preeminent storyteller of his generation and many that followed him.

Stevenson was always intrigued by the wider world, and in 1888 he left Scotland to travel to the South Seas, where he settled in Samoa. He made his life there until a lifetime of ill health caught up with him, and he died in 1894. He is buried on Mount Vea in Samoa.

 Continue along South Bridge for approximately 75 metres until you reach Blackwell's bookshop at **tulip. topic.enable**. Formerly James Thin bookshop, this was one of the oldest and

largest booksellers in the city. Founded in 1848 by James Thin, the bookshop initially specialised in academic books for the nearby University of Edinburgh, and also hymn books. Since then, Thin's became part of the academic and literary landscape of the city, until it was bought by Blackwell's in 2002 (which has since been taken over by Waterstones in 2022)

Turn right along Infirmary Street past Blackwell's and continue to the bottom of the street to reach Old Surgeons' Hall at **stud.drag.verse** – the site where Dr. Joseph Bell taught Arthur Conan Doyle, the creator of *Sherlock Holmes*

Refreshment stop – Infirmary Street

Mother India's Cafe at **forum.feeds.drops**.
An excellent option for some curry sustenance during the walk: Mother India's provides a tapas-style service so that you can sample a range of dishes on offer, including numerous vegetarian and vegan delights.

25 Retrace your steps from Old Surgeons' Hall back to South Bridge at **handy.fully.works**

26 Cross South Bridge and turn up Chambers Street at **slam.prom.mutual**

27 Approximately 60 metres along Chambers Street on the right-hand side heading west is Guthrie Street, which was the birthplace of Sir Walter Scott. A plaque on the wall at **noses.code.exact** notes the building where he was born

28 About halfway up Chambers Street is a statue of the publisher William Chambers, at **visa.exchanges.plus**. Along with his brother Robert, William Chambers made a significant contribution to the literary world with publication of the *Chambers English Dictionary*, first appearing in 1872

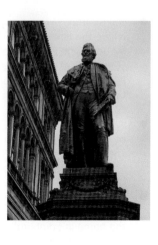

29 Walk to the end of Chambers Street and turn right onto George IV Bridge at **target.smug.hiding**

30 Walk south along George IV Bridge to finish the walk at Lawnmarket at **bland.known.brain**

More Literary Locations

There are literary locations all around Edinburgh, and some of the more notable ones include:

- Sherlock Holmes' statue on Picardy Place at the top of Leith Walk at **just.engage.loaf**. Near to where Arthur Conan Doyle, the creator of Sherlock Holmes, was born.

- Scotland Street in the New Town at **local.closed.snacks**, the site of a well-known series of eponymous novels by the local writer Alexander McCall Smith. The number of the street in the novels, 44, does not exist in real life.

- Sciennes House Place in the southside of the city at **hints.spoke.bank**, where Robert Burns and Sir Walter Scott had their only ever meeting, denoted by a plaque on the building.

- *Trainspotting* – numerous locations around the city, where the film of Irvine Welsh's book was produced, including the west end of Princes Street for the iconic "Choose Life" opening sequence; and 2 Wellington Place in Leith, Welsh's former home, at **lakes.nuns.roof**.

- Warrender Park Crescent at **form.alone.drip** – site of James Gillespie's High School for Girls, featured in *The Prime of Miss Jean Brodie* by Muriel Spark (now university accommodation).

- Abden House (now the Confucius Institute for Scotland) at **soaks.burst.lance**, in the grounds of Pollock Halls – the home in Edinburgh of John Buchan, the founder of the espionage novel, including *The Thirty-Nine Steps*.

- The Edinburgh International Book Festival, held every year during August in Charlotte Square at **linked.driver.fence**.

9 Dark Side Walk

As you investigate the streets of Edinburgh, particularly in the Old Town, it is not hard to imagine the range of murderous, devious or ghostly activities that have taken place over the centuries. This walk delves into some of the darker areas of Edinburgh's past, featuring a gallery of rogues and villains who have gone down in the annals of the city's criminal history.

This walk covers some of the sites where brutal punishments were meted out through the centuries, particularly to alleged witches, and deals with some of Edinburgh's most notorious criminals such as Burke and Hare, and Deacon Brodie. It also looks at some more unusual events, such as those that befell Half-Hangit Maggie.

Edinburgh lays claim to a rich heritage of ghostly happenings, and this walk passes the spots where some of these supernatural events are supposed to have taken place and explores the stories around them.

Dark Side Walk Introduction

This walk covers some of the more notorious events of Edinburgh's past – from the burning of witches to the murderous Burke and Hare, and numerous ghost stories.

Distance: 2.3 km. **Approx. number of steps**: 3,500.

Historical note – Edinburgh's Witches

Despite some claims that Edinburgh is the most haunted city in the world (most of them from ghost-tour companies), there are some truly sinister and disturbing events in the city's past. One of the most shameful is the killing of witches, when in the 15th and 16th centuries over 300 people (almost exclusively women) were put to death, mostly by burning (but generally not by drowning in the Nor' Loch, as is often claimed). A memorial to the people who died, known as the Witches Well (see above and page 176) adorns a wall at the top of Castlehill, at Castle Esplanade.

Starting Point

The Dark Side walk starts at the Mercat Cross, next to St. Giles' Cathedral on Lawnmarket at **what3words** ref: **spit.music.hung** – historically, the spot for civic proclamations and also for public punishments. The current Mercat Cross is topped by Scotland's national animal – the unicorn.

Walk Details

1 From the starting point, cross Lawnmarket to The Real Mary King's Close at **pills.parent.bring**. The Old Town is well known for its labyrinth of closes that link the main thoroughfares and contain hidden courtyards and

buildings. Even more hidden is The Real Mary King's Close, a collection of underground streets that used to bustle with residents of the Old Town. Tours can now be taken here, complete with ghostly stories about those who resided here through history

2 From The Real Mary King's Close, head west up the Royal Mile (Lawnmarket), towards Edinburgh Castle

3 Cross the road at Bank Street to Deacon Brodie's Tavern, which commemorates one of Edinburgh's most notorious criminals, at **star.choice.glitz**

Historical note – Deacon Brodie

Similar to Major Thomas Weir (see page 182), in that he had an outward appearance of respectability that hid a dark secret, Deacon Brodie has become famous for leading a double life, and it is thought that he was the inspiration for Robert Louis Stevenson's classic novel, *The Strange Case of Dr. Jekyll and Mr. Hyde*. William Brodie was born in 1741 in Brodie's Close at **star.choice.glitz**, near to the pub that now bears his name. Brodie became a skilled cabinet-maker, and this is where his title came from as he was Deacon of the Incorporation of Wrights. When his father died in 1782, Brodie inherited considerable wealth that should have set him up for life. However, he was an inveterate gambler, and the money soon began to disappear. Added to this, he was an adulterer who kept at least two mistresses. To finance his lifestyle, Brodie turned to housebreaking, copying the keys of his victims to gain access to their homes, and soon had a small gang of accomplices to help him with increasingly ambitious thefts. It was this compulsion to over-stretch himself that eventually led to Brodie's downfall, when he and his gang tried to rob the lucrative Excise Office. The gang was disturbed, and although Brodie fled, he was captured in Amsterdam in 1788 and returned to Edinburgh, where he was hanged on 1 October 1788.

4 Cross Lawnmarket and, still heading towards the castle, enter Riddle's Close at **hiding.bath.fault**

Historical note – Riddle's Court

Riddle's Court has a rich history, and has accommodated royalty and the power-brokers of Edinburgh society. Baillie John MacMorran developed Riddle's Court in the 1590s, but unfortunately he is also known for his untimely demise in 1595. Sent to quell a disturbance at the High School, MacMorran was shot and killed by one of the pupils, William Sinclair. Due to his age and well-connected family, Sinclair escaped any punishment, and the only casualty – apart from MacMorran – was the school's headmaster, who resigned due to the scandal of the affair.

5 Exit Riddle's Close and continue up Lawnmarket and then Castlehill to the castle

6 At the beginning of Castle Esplanade at the right-hand side is the Witches Well at **books.pops.dinner**. This is a memorial to approximately 300 people (mostly women) who were burnt at the stake or drowned during the 15th and 16th centuries. In 2022, the First Minister issued a formal apology to approximately 4,000 women and men who were historically accused, convicted and often executed under the Witchcraft Act of 1563

7 What is now Castle Esplanade is where many of the so-called witches were put to death, burnt at the stake

Historical note – Rough Justice

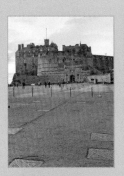

It is fair to say that, historically, wrong-doers in Edinburgh did not fare well if they were caught. Grisly executions were common, and the heads and body parts of those who were executed were frequently placed on poles around the city walls to deter any other would-be miscreants. High Street and Castlehill were popular locations, and one person to suffer a horrific and very public death was Walter, Earl of Atholl. The Earl was convicted of killing King James 1, and his execution was a litany of horrors stretched out over three days, much of which took place in Edinburgh's High Street. Another form of execution was known as The Maiden – Scotland's version of the guillotine. This was used for beheadings between the 16th and 18th centuries, and over 150 people were executed in this way. It is now on display in the National Museum of Scotland.

8 From Castle Esplanade, at the top of Castlehill, turn down Castle Wynd North at **bounty.tell. urgent**

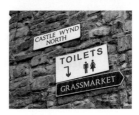

9 Walk down Castle Wynd North and turn right onto Johnston Terrace at **caller.preoccupied.lakes**. Head down Johnston Terrace, with the castle on your right-hand side

10 Continue along Johnston Terrace for approximately 500 metres as it curves to the left and becomes Spittal Street

Photo stop – Edinburgh Castle

As you head down Johnston Terrace, Edinburgh Castle looms above you on the right-hand side. This is an excellent opportunity to capture some dramatic photos of a side of the castle that is not always seen.
Two locations to capture shots from are:

lock.necks.regime

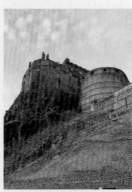

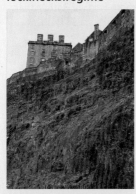

stews.limbs.today

11 Turn left onto Bread Street at **magma.trips.invite**. Walk approximately 100 metres along Bread Street, heading east to get to the top of West Port at **occupy.pops.plenty**, where two of Edinburgh's most notorious citizens, Burke and Hare, lived

Historical note – Burke and Hare

In the catalogue of Edinburgh's dark side, the names of Burke and Hare stand out as the most infamous of a motley crew. The slightly romanticised notion of Burke and Hare being grave-robbers belies the fact that they were, in reality, highly unpleasant characters who took to murder for profit. William Burke and William Hare were both from Ireland and gravitated to Edinburgh in the 1820s, moving into the same lodging house in Tanner's Close in the West Port (above) in 1826. In November 1827, one of the residents of the lodging house, "Old Donald", died, at which point Burke and Hare decided to profit from this by selling the body to a local anatomist, Dr. Robert Knox, since bodies were in high demand in the medical profession at this time. This seemed like easy money for Burke and Hare, and they sought more bodies. Rather than going down the route of becoming grave-robbers (resurrectionists), which was becoming increasingly difficult, they embarked on a murder spree to furnish Dr. Knox with bodies, prowling the dark streets of West Port, Grassmarket, and Cowgate to find their unfortunate victims. It is unclear how many murders Burke and Hare committed, but they were responsible for killing at least 16 people. When they were arrested in 1828, Hare turned King's evidence in return for his freedom. Burke was hanged on 29 January 1829, and his skeleton can be seen in the Anatomical Museum of the Edinburgh Medical School.

12 Head east along West Port for approximately 200 metres to reach Grassmarket. On the left-hand side as you walk along West Port is Argyle House, a utilitarian office block that belies its history, as it was on this spot that Tanner's Close sat – the lodging home of Burke and Hare

13 Walk up the left-hand side of Grassmarket to reach Maggie Dickson's pub at **traps.ideas.remind**. This is a location that immortalises a miraculous escape from the hangman's noose by a local who has become known as Half-Hangit Maggie

Historical note – Half-Hangit Maggie

Hangings were a common feature of Edinburgh life through the centuries, and many of them were conducted in the Grassmarket area. Most of these passed without incident, even though they were usually public events, but one of the most famous is the case of Maggie Dickson, known as Half-Hangit Maggie. In 1724, Maggie Dickson was sentenced to hang for concealing the death of her young baby while living in Kelso in the Scottish Borders. The hanging was a raucous affair, particularly as Maggie was known in Edinburgh and was a well-liked figure. After Maggie was pronounced dead, she was placed in a coffin and transported to nearby Musselburgh. Then, to everyone's amazement, noises came from the coffin, and when it was opened it was discovered that Maggie was very much alive. After considerable legal debate it was decided that she could not be hanged again, and she lived for another 40 years, forever known as Half-Hangit Maggie.

Refreshment stop – Grassmarket

In addition to being named after one of the most well-known characters to appear in the Grassmarket area, Maggie Dickson's pub at **traps.ideas.remind** is well worth a visit in its own right. If the weather is favourable there are seats outside for some al fresco refreshment, from where you can view the area where Maggie was "half-hangit"!

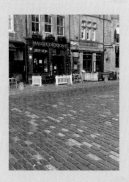

14 In the middle of Grassmarket, near to Maggie Dickson's pub, is the Covenanters' Memorial at

gone.frog.spit. This is a memorial to members of the Covenanter movement who were put to death for their beliefs

15 From the Covenanter's Memorial, cross to the right-hand side of Grassmarket to the entrance of Hunter's Close at **unfair.hotel.takes**, where there is a plaque marking one of Edinburgh's most infamous events – the Porteous Riots (see the next page)

Historical note – Porteous Riots

Contrary to its modern-day image, riots were a common occurrence in Edinburgh for hundreds of years, and it never took too much to cause an assembly of the mob. In March 1736 when two popular local smugglers were sentenced to death, the mob felt obliged to take action, particularly as the man in charge of maintaining law and order for the executions was a much-hated Captain of the City Guard, John Porteous. Before they were due to be executed, one of the men escaped, so Porteous became increasingly zealous about meting out punishment to the remaining prisoner. Following the execution, the City Guard and the watching mob confronted each other, leading Porteous to fire his pistol, which was followed by more shots from the Guard, killing three people. Porteous was put on trial, and although found guilty, he received a reprieve shortly afterwards, at which point the mob decided to take matters into their own hands. On 7 September 1736, they took Porteous from the city's Tolbooth jail, where he was being held until he was to be freed, and took him to the Grassmarket area where they hanged him from a dryer's pole.

Walk detour – Agnes Finnie

Although many of the women who were put to death after an accusation of witchcraft were innocent, there were some who seemed to embrace it. One of these was Agnes Finnie, who lived in the Potter Row Port area of the city in the first half of the 17th century, near **gear.tent.lake**. Agnes was an industrious but vindictive witch, and she would frequently render her victims helpless with a variety of unpleasant diseases. If anyone got into an argument with Agnes it could be a precarious business, resulting in broken limbs from fallen beams, falls from horses, blindness, and failing businesses. Agnes's behaviour caught up with her in 1644 when she was prosecuted with 20 charges of witchcraft and subsequently burnt at the stake in 1645.

16 From Hunter's Close, cross to the left-hand side of Grassmarket, and at the top of Grassmarket turn left into West Bow, which leads to Victoria Street at **elder.decreased.hero**

17 About halfway up Victoria Street, on Victoria Terrace above the shops, is the location of the home of a man who seemed to be the height of respectability, but who led a devious (and deviant) secret life – Major Thomas Weir

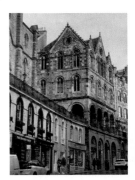

Historical note – Major Thomas Weir

There have been a number of Edinburgh citizens who appeared highly respectable on the surface but who harboured dark secrets. One of them was Major Thomas Weir, known as the Wizard of West Bow. Major Weir was a fiercely religious man and a staunch supporter of the protestant Covenanter movement. Weir was also a Captain of the City Guard, and he roamed the streets with a substantial staff, seeking to maintain law and order. However, in 1670 as he was nearing the end of his life, Major Weir made a startling confession: he had spent much of his adult life involved with the occult, adultery, bestiality, and incest with his sister Jean (known locally as Grizel). At first, the authorities were reluctant to believe Weir's confession, but Grizel added to the weight of evidence, suggesting that the Major's staff was used to summon the Devil. Stories of a burning, ghostly carriage pulled by black horses did little to help Weir's cause, and he and Grizel were both prosecuted and convicted of a range of crimes. Both were put to death in April 1670, with Weir refusing to ask for forgiveness, instead stating before his death, "Let me alone, I have lived as a beast and I must die as a beast".

18 Walk back along Victoria Street and turn left onto Cowgatehead at **best.frozen.await**

19 Continue west along Cowgatehead, which becomes Cowgate – a mixture of tall tenements, bridges, and narrow closes, many of which are claimed to be haunted

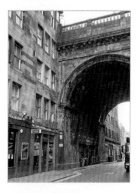

20 Continue through Cowgate and turn left up Blair Street at **puts.sofa.caller**

21 Halfway up Blair Street at **soft.good. depend** is the main office of Mercat Tours, one of the city's most popular providers of ghostly and murder-related tours, including tours of the Edinburgh Vaults. Now only accessible via tours, the Vaults are a group of chambers

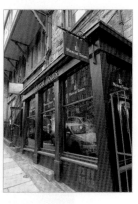

that were created below South Bridge when it was completed in about 1788. They were used for business for some years but then fell into disrepair, leading them to be used for a variety of criminal activities. As with many dark, damp areas of Edinburgh, numerous ghost stories have grown up around the Vaults

22 Walk to the top of Blair Street at **blank.cliff.richer** and walk through Hunter Square to return to High Street at the Tron Kirk at **ideas.camera.less**

23 Turn right and walk along High Street, until you reach Paisley Close on the left-hand side at **pool.score.rift**. Paisley Close is not a location where there were ghostly sightings or murderous activity, but rather a not uncommon problem in Edinburgh's Old Town

– a deadly collapsing tenement. This occurred in 1861, when one of Paisley Close's residents, 18-year-old Agnes Skirving, was visiting friends in Glasgow. While she was away, tragedy struck in the close, when one of the tenements collapsed, killing 35 people, including all of Agnes's family. However, there was one remarkable escape: as rescuers were searching through the rubble, they heard a plaintive cry of, "Heave awa lads, I'm no deid yet". The young man was rescued and his words are displayed on the motif above the entrance to Paisley Close

24 From Paisley Close, cross the road and retrace your steps back up High Street until you reach Bell's Wynd on the left-hand side at **admit.reveal.piles**

 Bell's Wynd is the
location of one of
Edinburgh's most
enduring ghost
mysteries, which were
easily spawned in
the dark corners of
the Old Town, like
those found in Bell's
Wynd. As with many
ghost stories, the
actual facts of this
one are conspicuous

by their absence, but it chimes with the area from
where it comes. The story concerns a locksmith
and blacksmith named George Gourlay and his
wife, Christian, who lived in Bell's Wynd around
the 1800s. George enjoyed frequenting the local
taverns, and it was here that he first heard stories
about the dwelling below his own that had
lain strangely quiet for nearly 20 years. George
was intrigued, and one night after an evening
in the tavern he decided to investigate. What
he discovered was a house that had obviously
been deserted in a hurry. He cautiously made his
way to the bedroom and, to his horror, found a
skeleton lying in the bed. This discovery, or the
drinks he had consumed in the tavern earlier, led
to the predictable appearance of a ghostly white
apparition floating down from the ceiling to the
bed. Equally predictably, George was terrified and
fled the building. An explanation for the dead body
was later provided by Christian, who it transpired
had previously worked for the occupants of the
house where the body was found. One evening its
owner, a Mr. Guthrie, returned home to find his
wife in bed with another man. In a rage, he killed
both of them and paid Christian to keep quiet
about what she had seen, which she did until the
grisly discovery of the body by George

 From Bell's Wynd, walk approximately 100 metres
up High Street to the walk's starting point

More Dark Side Locations

Edinburgh is rife with stories of murder, intrigue and numerous ghostly sightings. Some of the most infamous ones over the years include:

- **Greyfriars Kirkyard** at **foam.buyers. hooks**. Many ghost stories surround the Kirkyard, partly due to the eerie nature of the Kirkyard at night. It is also the location of a mortsafe at **movie.native.stud** in the Kirkyard, which was used to deter grave-robbers who roamed the city.

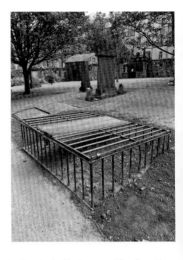

- **81a George Street** at **shade.left.singer**. The location of a notorious murder involving a Frenchman, Eugene Marie Chantrelle, who made his life in Edinburgh as a teacher, and his wife Elizabeth. Shortly after their marriage, Elizabeth realised that her husband was an erratic and abusive character and, after several years, she sought advice about getting a divorce. Around the same time, Chantrelle took out life insurance for his wife, with a specific clause regarding accidental death. On the night of New Year's Day 1878, Elizabeth fell ill, with Chantrelle's behaviour being evasive with the servants in the house. He tried to convince a visiting doctor that Elizabeth had fallen ill from coal-gas poisoning but the doctor was unconvinced. When Elizabeth died shortly afterwards on 2 January, the doctor's suspicions were soon confirmed: Chantrelle was accused of poisoning his wife with opium. He was found guilty of her murder in May 1878 and hanged shortly afterwards.

- **17 Danube Street** at **chefs.poet.fake**. The location of a modern-day brothel that was run by Dora Noyce until her death in 1977. Noyce was charged nearly 50 times for living off immoral earnings, but freely admitted the charges and paid the fines promptly. Danube Street was widely used by all sectors of Edinburgh society, tourists, and sailors. Its particular notoriety was partly due to the refined nature of Danube Street, compared with the activities being undertaken at number 17.

- **The Green Lady of Morningside**. Morningside is one of the most sought-after areas of Edinburgh, but it too is not immune from stories of a dark nature. One of these dates back to 1712 when a respected former governor of Maryland in the colonies, Sir Thomas Elphinstone, returned to Edinburgh and set up home at the end of Balcares Street in Morningside, near **open. clap.couches**. Sir Thomas was a widower, but soon started to court a much younger local woman, Betty Pittendale. Betty was reluctant to marry Sir Thomas because of a torrid love affair with an army captain named Jack Courage, but when he was posted to Ireland, Betty agreed to marry Sir Thomas. A few months later, Sir Thomas' son returned to see his father but when he was introduced to his new bride, Betty was stunned to see that it was Jack Courage. Betty and Jack quickly resurrected their affair, only for Sir Thomas to discover them and stab Betty to death in a rage while she was wearing a green dress. The next day, filled with remorse, he killed himself, and Jack left the family home. It was later rented out to family friends who reported numerous occurrences of hauntings in the house by a woman wearing a green dress, matching the one that Betty was wearing when she died. The residents of the house eventually tried to exorcise the ghost of the Green Lady, by using a mystic from India. This was apparently successful, and the body of the Green Lady was said to be lying in an open coffin, with a peaceful look on her face. It is also said that the body of Jack Courage was eventually laid to rest next to his lover.

- **Queensberry House**, Canongate at **before.league.sports**. Now part of the Scottish Parliament at the bottom of the Royal Mile, Queensberry House was the site of a particularly grisly death in 1707, during the signing of the Acts of Union joining Scotland and England. On the day of the signing, the Duke of Queensberry and most of the staff from Queensberry House had gone to Parliament Square at the Lawnmarket area of the Royal Mile to witness this historic occasion, leaving only one young kitchen boy in the house. However, unknown to most people, there was also one other resident in the house – the Duke's son, who had to be locked in a ground-floor room because of his wild and erratic behaviour. Since the manservant guarding him had also left for the Acts of Union celebrations, the wretched soul was free to roam the house, and he came across the kitchen boy roasting food over the fire. What exactly transpired is not known, but when the residents of the house returned, they found the roasted food lying on the floor of the kitchen and the poor kitchen boy dead on the spit over the fire. Stories abounded about ghostly sightings after this horrific event, which is probably not surprising given the circumstances of what occurred in the kitchen. For years to come, members of the house also refused to set foot in the kitchen. The full horror of the events in Queensberry House became evident in 1926 when restoration work uncovered the fireplace and the skeleton of the tragic kitchen boy.

- **Dalry House**, Orwell Place at **trick.tanks.having**. The location of the ghost of Johnny One-Arm of Dalry. Originally known as John Chiesley, he shot and killed the Lord President of the Court of Session in 1689, after a divorce proceeding did not go to his liking. Chiesley was hanged, and the hand used to fire the pistol cut off. His body was stolen, and for hundreds of years Johnny One-Arm was thought to be haunting his home of Dalry House and the surrounding area. In 1965, a one-armed skeleton was found in a house being renovated, and after that the mysterious hauntings stopped.

10 Water of Leith Walk

This is a charming walk that is part of the longer Water of Leith walk, which winds all the way from the village of Balerno outside Edinburgh to the historic Edinburgh port of Leith. Although some short sections go through the city streets, the majority of it is through wooded areas, and even though much of it takes place within 15 minutes or so of the city centre, it is possible to imagine that you are in the middle of the countryside.

The walk takes you from the historic and picturesque Dean Village to the Royal Botanic Gardens. Following the Water of Leith, it goes through Stockbridge, one of the most sought-after areas of the city, and includes points of interest such as the pineapple-topped St. Bernard's Well and the Colonies area of Stockbridge, with its novel design of houses. But most of all, the walk is an antidote to the hustle and bustle of the city centre, and offers some peace and tranquillity without having to go too far from the heart of the city.

Water of Leith Walk Introduction

This walk offers a tranquil break from the bustling city streets and, as you meander along the banks of the Water of Leith, it is sometimes hard to believe you are in a city.

Distance: 2.6 km. **Approx. number of steps**: 4,000.

Historical note – Dean Village

Dean Village is one of the most picturesque areas of Edinburgh. It is dominated by the towering Dean Bridge, built by Thomas Telford between 1829 and 1831, which linked the expanding New Town with what was once an industrial suburb lined with mills generating power from the Water of Leith. Despite its proximity to the city centre, Dean Village retains a considerable olde-worlde charm.

Starting Point

The Water of Leith walk starts at Dean Village. Get there by following the directions for the Dean Village photo on page 101, or from at the top of Hawthornbank Lane, 15 minutes' walk from the city.

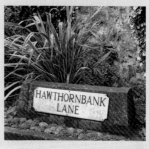

At **what3words** ref: **drill.simple.appear**, turn left along Hawthornbank Lane.

Walk Details

1 Continue along Hawthornbank Lane until you reach the heart of Dean Village at **soils.exam.robe**, for the photo on the opposite page

2 Heading east, walk along the cobbled street, with the large yellow house (Hawthorn Buildings) on your right and the Water of Leith on your left

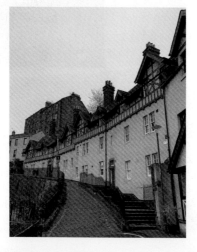

3 When you reach Dean Path bridge at **sheep.feast.title**, walk straight on, along Miller Row, past the sign for St. Bernard's Well and Leith

4 Continue along Miller Row for approximately 500 metres, passing under Dean Bridge at **stacks.upon.grant**

5 At **flash.sheet.moment**, St. Bernard's Well is on your left-hand side

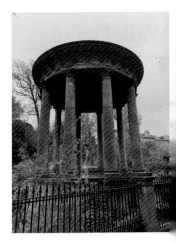

Historical note – St. Bernard's Well

Built in the Greco-Roman style, St. Bernard's Well was used for centuries, from the 18th century onwards, for the medicinal powers of its waters. The well is named after a 12th-century monk who was said to have lived in a nearby cave. The healing powers of St. Bernard's Well came to an abrupt end in 1940, when the waters were found to contain arsenic.

6 Look out for the golden pineapple on the top of St. Bernard's Well and a statue of Hygieia – the Greek and Roman goddess of health and cleanliness – in the middle

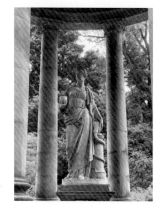

7 From St. Bernard's Well, continue along the path for approximately 150 metres, passing Dean Gardens on your left-hand side at **talked.little.scans**

8 Go under St. Bernard's Bridge at India Place, exiting onto Saunders Street. Look out for the colourful street sign on the left-hand side at **attend.mice. firmly**

9 Walk to the end of Saunders Street until you reach the junction with Kerr Street. You are now in the heart of Stockbridge

10 Cross over Kerr Street, turn left, and cross the bridge over the Water of Leith (Stockbridge). Walk down the steps at the end of the bridge at **trim.chip.affair** to join the Water of Leith Walkway

Historical note – Stockbridge

Stockbridge is one of Edinburgh's most desirable districts, and was developed as part of the expansion of the original New Town as the city sought more space for its residents. With its close proximity to the Water of Leith, its design was not as ordered as for the grid of the First New Town, but its stock of good-quality housing soon attracted a mixture of Edinburgh citizens, giving the area a vibrant and community feel that it retains today.

11 The Water of Leith Walkway follows along the left-hand side of the Water of Leith for approximately 300 metres

Refreshment stop – Stockbridge

Stockbridge is bursting with excellent restaurants, pubs and cafés. Sometimes it feels like you cannot walk for more than a couple of minutes without passing some type of refreshment establishment. One option to try is **Bells Diner** at **wins.forced.passes** – something of a Stockbridge tradition, particularly for steaks and burgers.

12 At the end of the Water of Leith Walkway where it joins Falshaw Bridge, turn left onto Bridge Place at **basis.monkey.limes**

13 Pass the Water of Leith Walkway sign and walk approximately 50 metres, then turn right onto Arboretum Avenue at **harp.lower.patch**

14 Continue along Arboretum Avenue, with the Water of Leith on your right-hand side, for approximately 300 metres, until you reach the gates for Rocheid Path at **rush.zooms.having**

15 Enter Rocheid Path and pass the information board on your left-hand side. The path offers a short (approximately half a kilometre) but peaceful walk through a picturesque woodland area, with the Water of Leith on your right-hand side

Historical note – Rocheids

The Rocheids were an affluent family who bought the land around Rocheid Path in the 1600s. Over a century later, in 1774, the Rocheids built Inverleith House, which now serves as an art gallery in the nearby Royal Botanic Gardens. In 1823, the Rocheids agreed for some of their land to be used as development for the Royal Botanic Gardens, and it opened here on its new site in 1824, having previously occupied what is now Platform 11 at Waverley Station.

16 Continue along Rocheid Path until you reach Bell Place Bridge at **pounds.income. thing**. Cross the bridge to investigate the Colonies area of Stockbridge, or continue along Rocheid Path

The Colonies area dates back to around 1870 when local stonemasons grouped together to build affordable housing for their associates and other craftsmen. The houses are notable for having a dwelling with a ground floor on one side of the building and an upper-floor dwelling on the opposite side, with a front door at the top of steps.

 Pass Tanfield Bridge (see photo stop below) and exit Rocheid Path at **solve.tides.oath** onto Summer Place

Photo stop – Tanfield Bridge

Tanfield Bridge crosses the Water of Leith from Rocheid Path at **fills.intent.mice**, and provides a tranquil photo opportunity.

18 Walk approximately 130 metres to the end of Summer Place, where it joins Inverleith Row at **hang.vast.wink**

19 This is the end of the walk, but there are further options available. Turn left along Inverleith Row and walk approximately 150 metres to the East Gate entrance of the Royal Botanic Gardens at **assist.crowds. gentle**

20 To return to the city centre, cross Inverleith Row, turn right, and walk approximately 120 metres to the bus stop at **wrong.takes.hero**. Catch a number 23 or 27 to return to Princes Street, alighting on Hanover Street

21 To continue along the Water of Leith, cross the road and turn right along Inverleith Row. Walk approximately 250 metres until you reach Warriston Road at **remind.beast. terms**. Turn left along Warriston Road to continue the Water of Leith walk

22 Walk approximately 600 metres along Warriston Road and turn right onto the path at **singer.nuns.fees**. Follow the path and the Water of Leith

Walkway signs for approximately 3.5 kilometres, until the Water of Leith reaches the sea at the Albert Dock Basin in Leith Docks. Nearby are the Royal Yacht Britannia and the Ocean Terminal shopping centre (see page 200 for details)

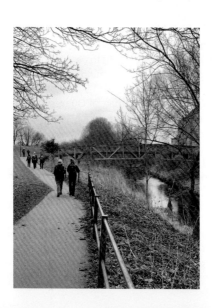

More Water of Leith Locations

From Dean Village all the way to Leith Docks at the end of the Water of Leith, there are numerous interesting locations and points of interest. Some of them include:

- **Scottish National Gallery of Modern Art**, 75 Belford Road, at **remove.bless.curry**. Walk west for approximately 775 metres along the path over the bridge at Step 1 of the walk to reach this impressive collection of modern and contemporary art.

- **West Mill**, Dean Path, at **drew.birds.royal**. One of several mills that made the most of the water supply from the Water of Leith to power their businesses, many of which ground wheat for flour.

- **Stockbridge Market**, Jubilee Gardens, at **apples.reach.loss**. Held every Sunday 10:00-16:00, offering excellent local produce.

- **Duncan's Land**, 4/1 India Place, at **editor.emerge.happy**. The birthplace of the well-known Victorian painter David Roberts (1796-1864).

- **Glenogle Baths**, Glenogle Road, at **label.store.cute**. Over 100 years old, the baths are a fine example of traditional Victorian swimming baths.

- **The Kitchin**, 78 Commercial Quay, Leith, at **gave.sounds.custom**. A highly-regarded Michelin restaurant in the heart of Leith.

- **Royal Yacht Britannia**, Ocean Drive, at **crib.having.tried**. The former yacht of the Royal family, now moored in the Albert Basin Dock. Tours can be taken on the Royal Yacht, which also has a café.

- **Ocean Terminal**, Ocean Drive, at **intend.chop.list**. Near to the Royal Yacht, a modern shopping centre with something for every shopper.

11 Arthur's Seat Walk

Like the Water of Leith walk, this walk offers an abundance of green spaces in the very heart of the city, with Edinburgh Castle still clearly visible.

There are many ways to walk up and around Arthur's Seat, and this one takes in one of the most common routes to the summit. From there, the walk can be continued, or you can backtrack to the starting point.

The walk not only details the route for Arthur's Seat but also explains some of the history of this extinct volcano, and people who have made a name for themselves there.

There are also excellent photo opportunities from the summit of Arthur's Seat and the slightly lower Salisbury Crags, and these are covered so that you can still make photographic contributions as you enjoy the bracing air on Arthur's Seat and the surrounding scenery.

Arthur's Seat Walk Introduction

As with the Water of Leith walk, this walk offers plenty of green space within view of the city centre. Although there is a path most of the way to the summit, a sturdy pair of walking shoes is recommended, and it can be very windy at the summit so it would be wise to take a coat!

Distance: 3.2 km, there and back; 5 km, circular.
Approx. number of steps: 4,800 or 7,500.

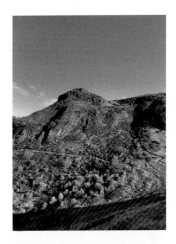

Historical note – Arthur's Seat

Arthur's Seat is an extinct volcano, rather than a dormant one. Its summit stands approximately 2.5 kilometres from Edinburgh Castle (as the crow flies), and it sits overlooking the city like an watchful elderly relative. Originally, it was discussed as the seat of power for the new city – a debate that was eventually won by Castle Rock. Its summit is 250 metres (822 feet). It has been home to various hill forts and small communities over the centuries, and large bonfires were frequently lit to celebrate significant events.

It is an Edinburgh tradition for people to climb to the summit of Arthur's Seat on Christmas Day.

Starting Point

The Arthur's Seat walk starts at the beginning of the path to the summit, located on Queen's Drive near to Holyroodhouse Palace at **what3words** ref: **visa.ever.rider**. See the Holyroodhouse Palace photo site on pages 94-95 for details about reaching the starting point.

Walk Details

1 From the starting point, walk along the path for 300 metres to a fork in the path at **best.closes.seats**, passing St. Margaret's Well on the left-hand side

Historical note – St. Margaret's Well

St. Margaret's Well was relocated to its current location from the nearby Restalrig area, to accommodate new railway construction in 1860. The well is a Gothic design, with a grotesque figure where the water flows from the spring below. The spring is considered to be holy, and has a connection with King David I who founded a nearby abbey in 1128 that went on to become Holyroodhouse Palace.

2 Take the left-hand fork in the path and continue along the path for 220 metres, with St. Margaret's Loch on the left-hand side, passing St. Anthony's Chapel at **pinch.device.medium**

Historical note – St. Anthony's Chapel

This ruined chapel is named after the patron saint of lost things, and its own history has also largely been lost in the mists of time. It is thought to have been built at the start of the 15th century. It may have been used as a site for pilgrimage. The last chaplain left in 1581, after which the chapel fell into ruin, but it remains a popular photo spot.

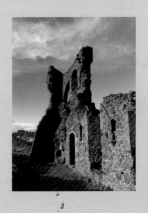

3 At **wires.tube.decreased**, continue on the path as it turns to the right

Refreshment stop – Picnic

There are several locations on the way to the summit of Arthur's Seat that are ideal for a picnic or a short break. The most important consideration is to make sure that you are sheltered from the wind, which can get stronger the closer you get to the summit.

4 Follow the path for 580 metres, with Salisbury Crags on the right-hand side, until the path reaches the next fork at **aside.fingernails.aspect**. Follow the path for 125 metres to **boss.could.natively**

5 This is at the foot of the summit of Arthur's Seat, and there are two options for reaching the summit: scramble straight up the rocks from the path, or follow the stone path with the metal chain on the right-hand side of the path. Reach the summit at **angle.shave.bucket**

Historical note – Bonnie Prince Charlie

Bonnie Prince Charlie cemented his place in Scottish history with his ill-fated Jacobite rebellion in an attempt to place a Stuart king on the throne. In 1745, the prince arrived in Scotland from France and marched on Edinburgh. He achieved a notable victory over the British army at the Battle of Prestonpans, and adopted Holyroodhouse Palace as his centre of power, with his army camped at the foot of Arthur's Seat. However, this was the pinnacle of his achievements: an unsuccessful foray into England was followed by a disastrous end to the Jacobites' aspirations, with a crushing defeat at the Battle of Culloden in 1746.

Photo stop – Arthur's Seat Summit

The summit of Arthur's Seat is an excellent location for capturing cityscape shots (if you can keep the smartphone camera steady in the wind!). A similar shot can be captured from the top of Salisbury Crags at **wanted. slang.gross**.

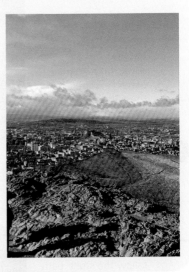

6 From the summit there are two options: return via the route taken to the summit, or continue the walk via Dunsapie Loch and then walk around the bottom of Arthur's Seat

7 To continue the walk, walk down from the summit for approximately 170 metres heading east, to **shares. crowned.safe**

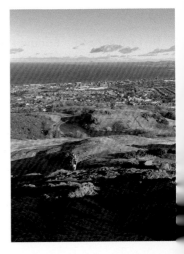

8 From here, follow the path for approximately 400 metres to Dunsapie Loch car park on Queen's Drive at **tags.joined. fees** (there are several paths here, but they all lead down to Dunsapie Loch)

Walk detour – Sheep Heid Inn

As you walk along Queen's Drive there is a path to the left at **branded.photos.cube**, approximately 120 metres from Dunsapie Loch car park in Step 8. Take this path and follow it for approximately 280 metres to **flash.exam.rating**. Turn left and walk 80 metres to **idea.until.rods**, to the Sheep Heid Inn pub and restaurant in the village of Duddingston. The Sheep Heid Inn is a charming establishment that is well worth a visit, if only for its indoor skittles alley.

9 Turn right onto Queen's Drive and follow the road for approximately 1.5 kilometres, with Arthur's Seat on your right-hand side

10 As you continue along Queen's Drive, the village of Duddingston and Duddingston Loch can be seen on your left-hand side at **lunch.pasta.pull**

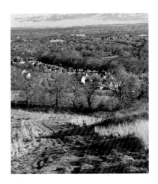

Walk detour – Salisbury Crags

Approximately 150 metres before you reach the mini-roundabout in Step 11 on the next page, there is a path that forks to the right at **unrealistic.toxic.sweep**. Just beyond this to the left is the Radical Road path, which goes along the foot of Salisbury Crags. However, due to the danger of falling rocks, this has been closed since 2019, with no immediate prospect of it reopening. Instead, follow the path for 100 metres and take the fork to the left at **waddle.bets.sends**. Continue along this path – which goes along the top of Salisbury Crags – for approximately 1.2 kilometres to return to the walk's starting point. Good photo opportunities of the city are available from the top of the crags.

 11 On Queen's Drive at **actors.switch.sang** is a mini-roundabout

Refreshment stop – Picnic

In good weather, the area of grass at **given.years.splice**, near to the mini-roundabout in Step 11, is an excellent spot for a picnic or a rest after walking up Arthur's Seat. The area is a particular favourite with students from the nearby Pollock Halls student accommodation.

 12 Continue straight ahead at the mini roundabout and continue along Queen's Drive for approximately 1.4 kilometres to return to the walk's starting point

Historical note – Radical Road

Although currently closed, Radical Road running below Salisbury Crags retains significant historical importance. It was in this area that geologist James Hutton (1726-97) did much of his research work that led him to calculate that Earth was a lot older than previously thought. The southern section of Radical Road is now known as Hutton's Section in honour of his work. The Radical Road path was built by unemployed workers from the west coast of Scotland following the Radical War of 1820, which was a workers' uprising in protest about working conditions.

More Arthur's Seat Locations

Considering its height over the city, it is not surprising that a number of interesting local sights can be seen from the top of Arthur's Seat, although they may not necessarily be in close proximity. Some of those include:

- The Royal Commonwealth Pool – the city's largest swimming pool, at **what3words** ref: **silent.barn.bigger**, with one main swimming pool, a children's pool, a diving pool, and flumes. It has been used for the Commonwealth Games on the two occasions they were held in Edinburgh – in 1970 and 1986.

- On a clear day, the Bass Rock can be seen from the summit of Arthur's Seat looking east, at **also.acoustics.sheet**. Containing a lighthouse, a ruined castle, and a chapel, it is best known as an important breeding ground for gannets. Tours can be taken from the excellent Scottish Seabird Centre in nearby North Berwick.

- Registers of Scotland. From the summit of Arthur's Seat looking north, you can see Registers of Scotland at **lobby.lion.last**. This is a department of the Scottish Office that holds numerous registers including the Land Register, which is the bedrock for property ownership in Scotland.

- It takes good eyesight or a pair of binoculars, but Edinburgh Zoo can be seen in the distance from the summit of Arthur's Seat looking west, at **meals.media.fetch**. With pandas and giraffes being among the attractions, the zoo is committed to conservation and has a range of breeding programs.

Index